Dale,

Sharing a bit of where I'm from. :)

Merry Christmas!

Penny

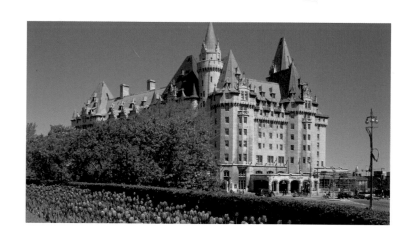

OTTAWA

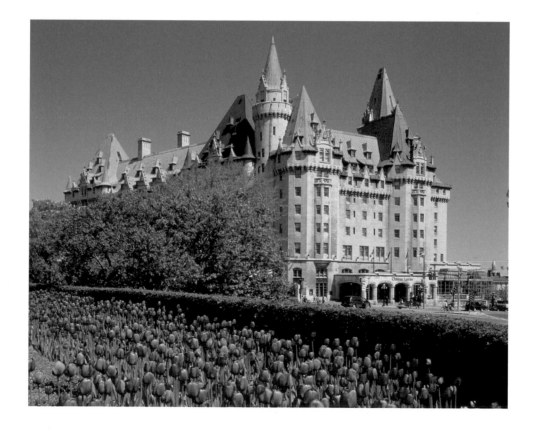

WHITECAP BOOKS
VANCOUVER / TORONTO

The information in this book is true and complete to the best of our knowledge.
All recommendations are made without guarantee on the part of the author or
Whitecap Books Ltd. The author and publisher disclaim any liability in connection
with the use of this information. For more information please contact Whitecap
Books Ltd., 351 Lynn Avenue, North Vancouver, B.C., V7J 2C4.

Cover and book design by Steve Penner
Cover photograph by J. Cochrane / First Light
Text by Tanya Lloyd
Edited by Elaine Jones
Proofread by Lisa Collins
Photo editing by Pat Crowe

Printed and bound in Canada by Friesens, Altona, Manitoba.

Canadian Cataloguing in Publication Data

Lloyd, Tanya, 1973-

 Ottawa

ISBN 1-55110-527-6

 1. Ottawa (Ont.)--Pictorial works. I. Title. II. Series:
Lloyd, Tanya, 1973-
FC3096.37.L66 1997 971.3'3804'0222 C960910736-6
F1059.09L66 1997

The publisher acknowledges the support of the Canada Council and the
Cultural Services Branch of the Government of British Columbia in making
this publication possible.

**For more information on this series and other Whitecap Books
titles, visit our web site at www.whitecap.ca.**

The dazzling yellow of tulips, the grandeur of the Parliament Buildings, and the laughter of skaters on the Rideau Canal—these are vibrant images typical of Ottawa. Canada's capital is known as a quiet city, filled with recreational opportunities and surrounded by parkland. Ironically, the city began as a piece of military strategy. After the War of 1812, tension between the British and Americans was still strong, and the Americans held a vital portion of the St. Lawrence River. The British decided to build a canal connecting the Ottawa River to Lake Ontario and placed Lieutenant-Colonel John By in charge. The base at the picturesque confluence of the Ottawa, Gatineau, and Rideau rivers was soon christened Bytown. In 1855, it was renamed Ottawa and two years later Queen Victoria named it capital of the province of Canada.

Critics suggested that the Queen closed her eyes and pointed blindly to the map. They dubbed the city "Westminster in the Wilderness" and considered it a backwoods mix of farmers and lumberjacks. In some ways, however, Ottawa was an ideal choice. It was central, economically prosperous, and removed from the tension of the border. At Confederation in 1867, the Parliament Buildings were already underway, and Ottawa became the capital of a new nation.

Today, Ottawa is a city of just over 300,000 people, filled with cultural attractions, historic buildings, and a natural beauty that continues to strike patriotic chords in Canadian visitors. It attracts more than 4 million tourists a year, who come to tour Parliament Hill, stay in the luxurious Chateau Laurier, and explore the 45,000 works of art held by the National Gallery of Canada.

Despite its military beginnings, the city is filled with symbols of peace. The most prominent, the Peace Tower, honours those who fought in the two World Wars. Another symbol blooms each spring—an annual gift of tulips from the Netherlands, in gratitude for Canada's liberation of Holland and hospitality towards the Dutch royal family during World War II. And at the city's centre, the canal built in a time of hostility is today used mostly by pleasure boats in the summer and skaters in the winter.

When Thomas Fuller and Chilion Jones designed Canada's Parliament Buildings in 1859, the Gothic Revival-style arches were lined with eye-catching red sandstone. When the structure was rebuilt after a fire in 1916, architects followed a similar but less colourful style.

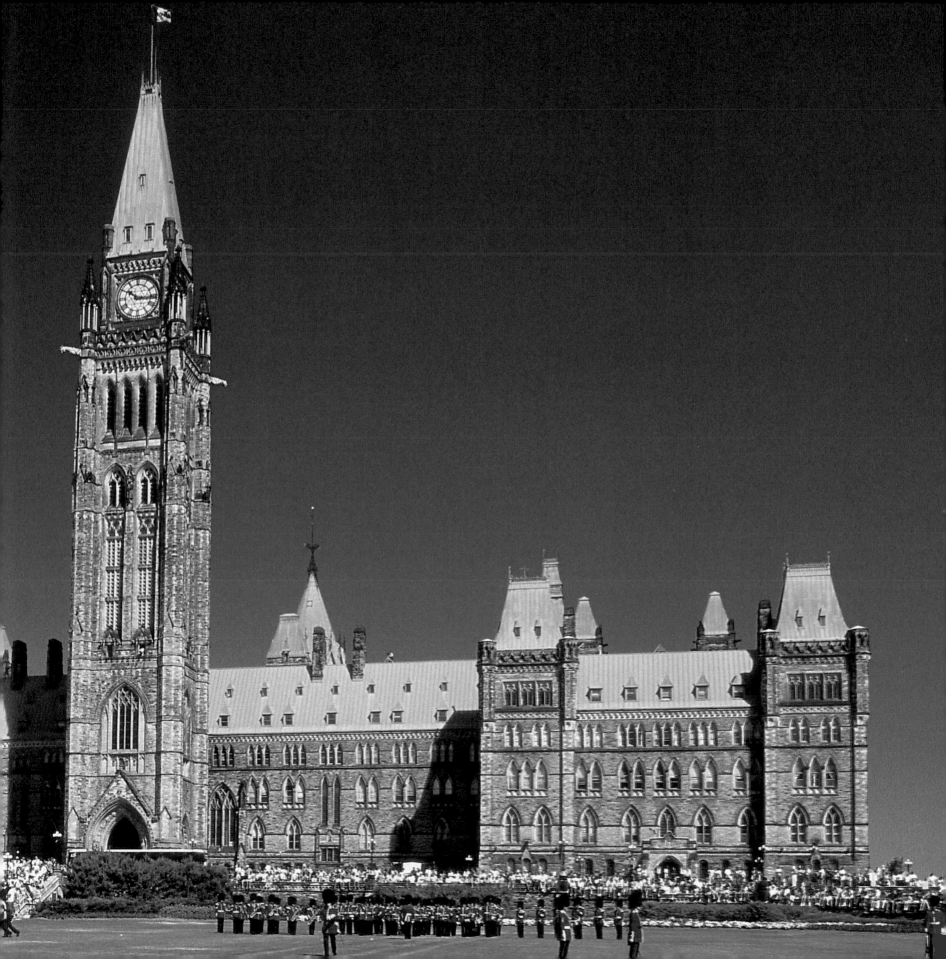

A band accompanies the Governor General's Foot Guards and the Canadian Grenadier Guards as they march from Cartier Square to Parliament Hill in preparation for the Changing of the Guard ceremony. Held each summer morning, the ceremony includes dress and weapons inspections, parading of the colours, and the exchange of compliments between the old and new guards.

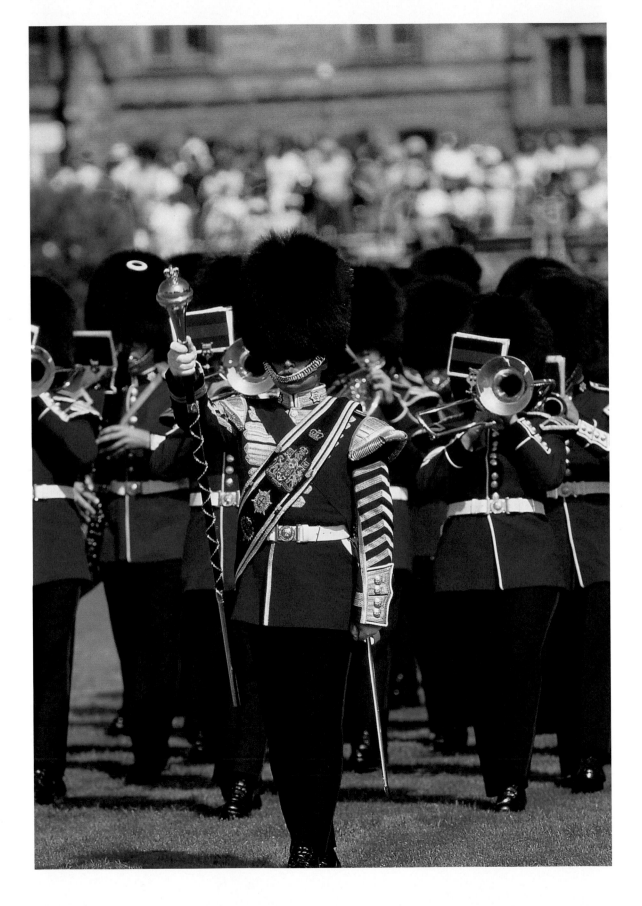

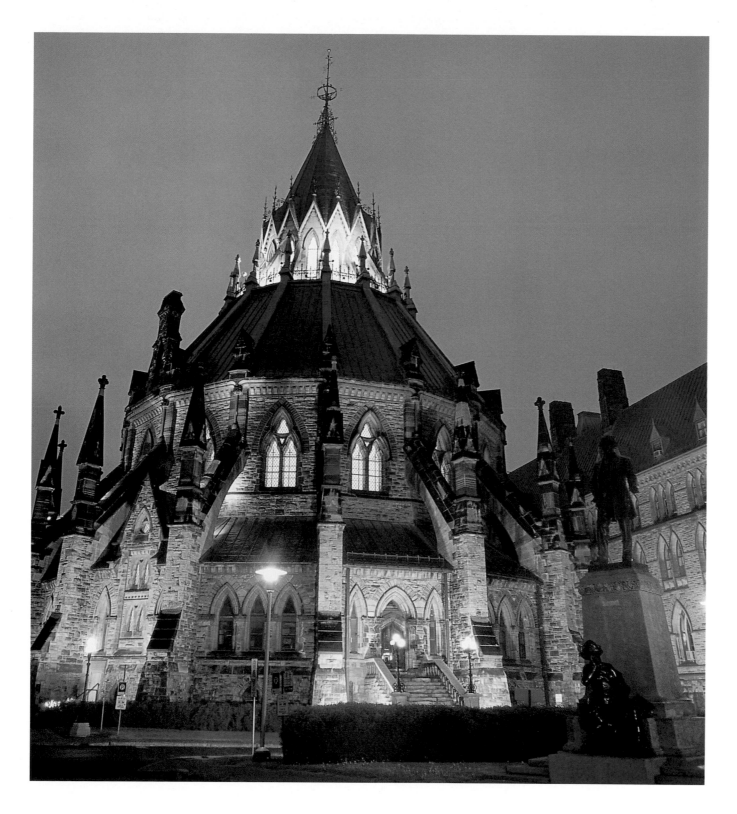

The only part of the Parliament Buildings not destroyed by the 1916 fire, the Library of Parliament holds an extensive collection of books and antiques, many of them priceless.

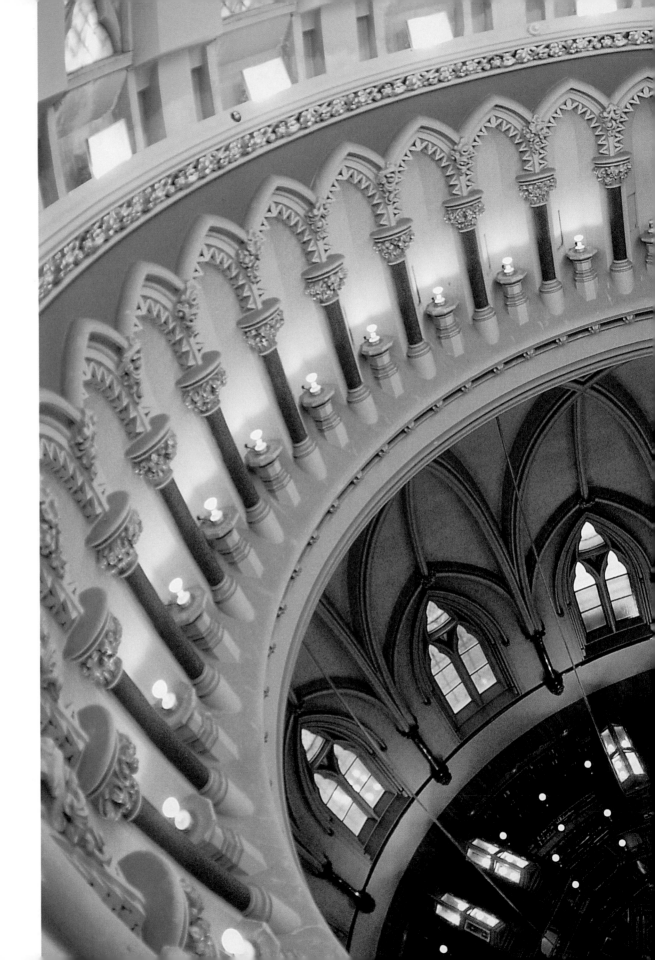

The library's octagonal interior is beautifully constructed in iron and native woods: white pine, oak, cherry, and walnut.

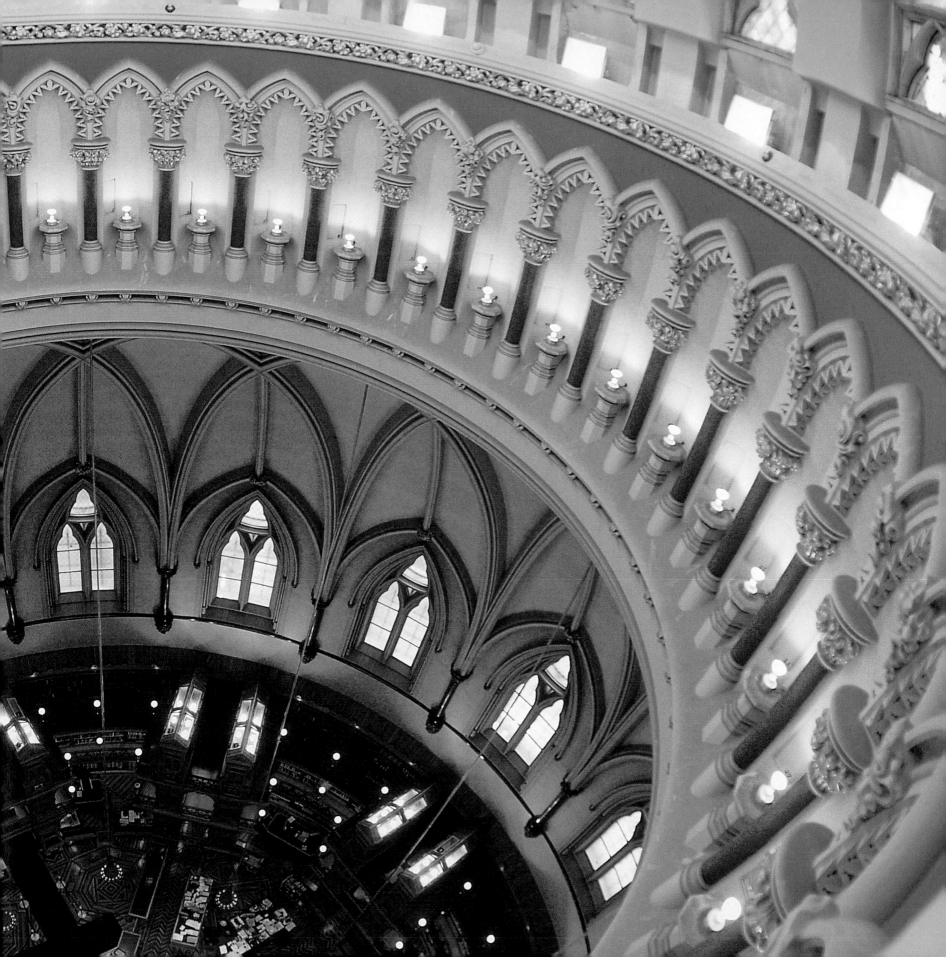

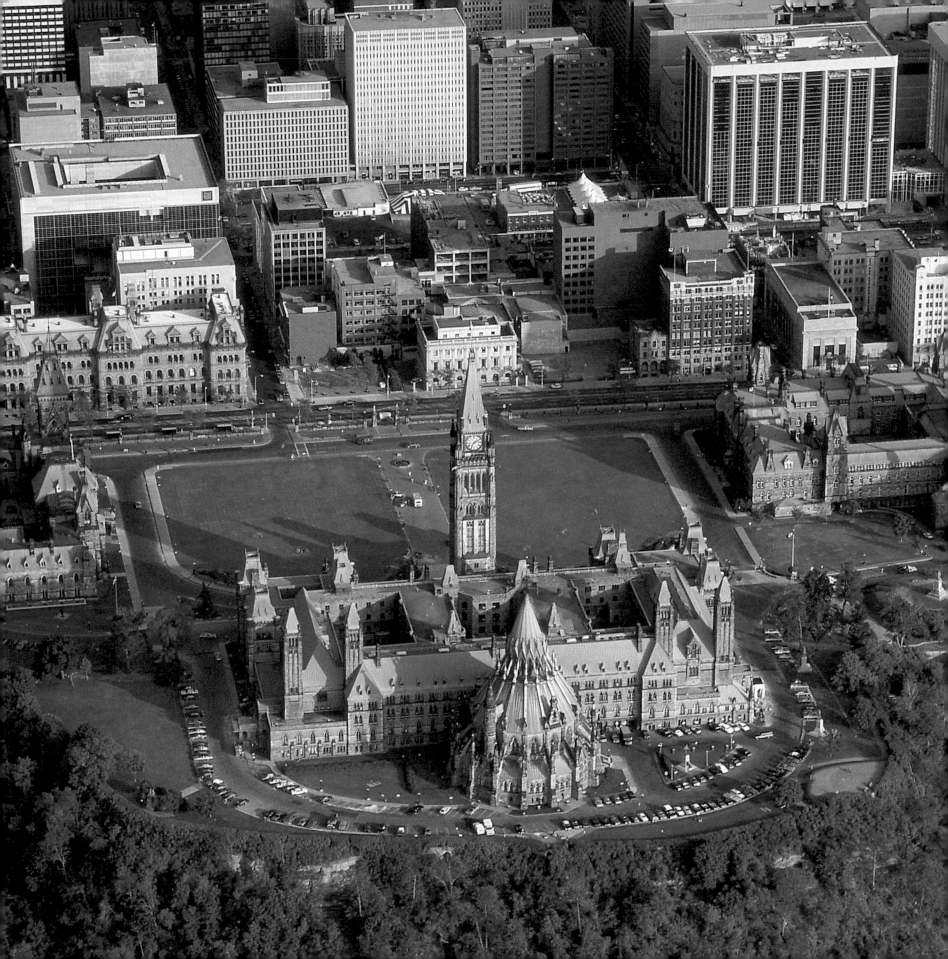

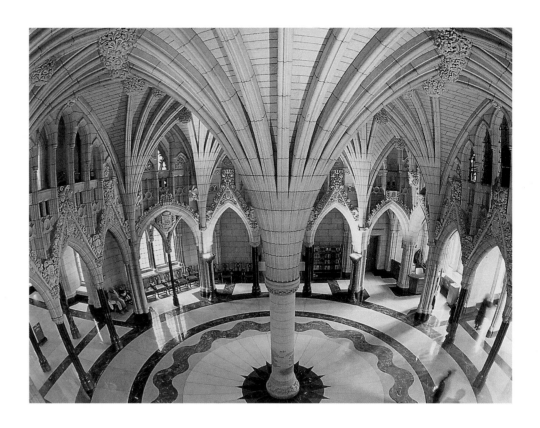

The connecting arches of the Parliament Buildings' immense entrance, Confederation Hall, are symbolic of the uniting of Canada's provinces. One of the arches bears a carving of *Grande Hermine*, the ship that carried explorer Jacques Cartier down the St. Lawrence River.

Parliament Hill, or "the Hill," as it is known locally, is a promontory overlooking the Ottawa River. Rising in the centre of the Parliament Buildings, the Peace Tower honours those who fought in the two World Wars. The names of more than 100,000 Canadian soldiers who died in the line of duty are inscribed within.

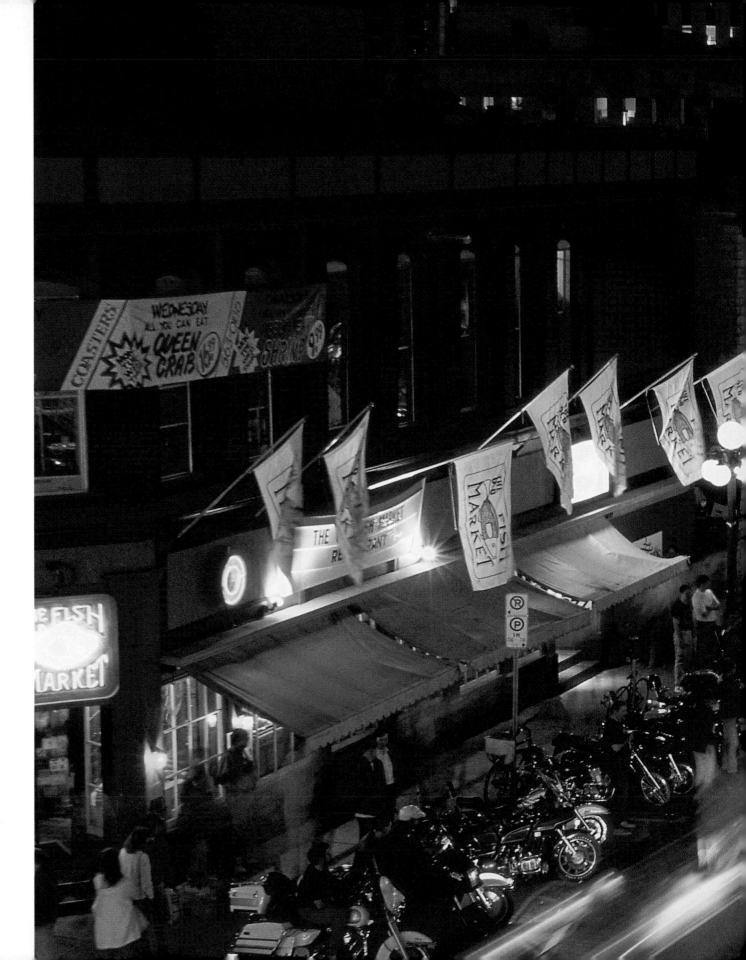

Motorcycles line the brightly lit sidewalks outside Byward Market. With restaurants, shops, and bars, the market is as popular in the evenings as it is during the day.

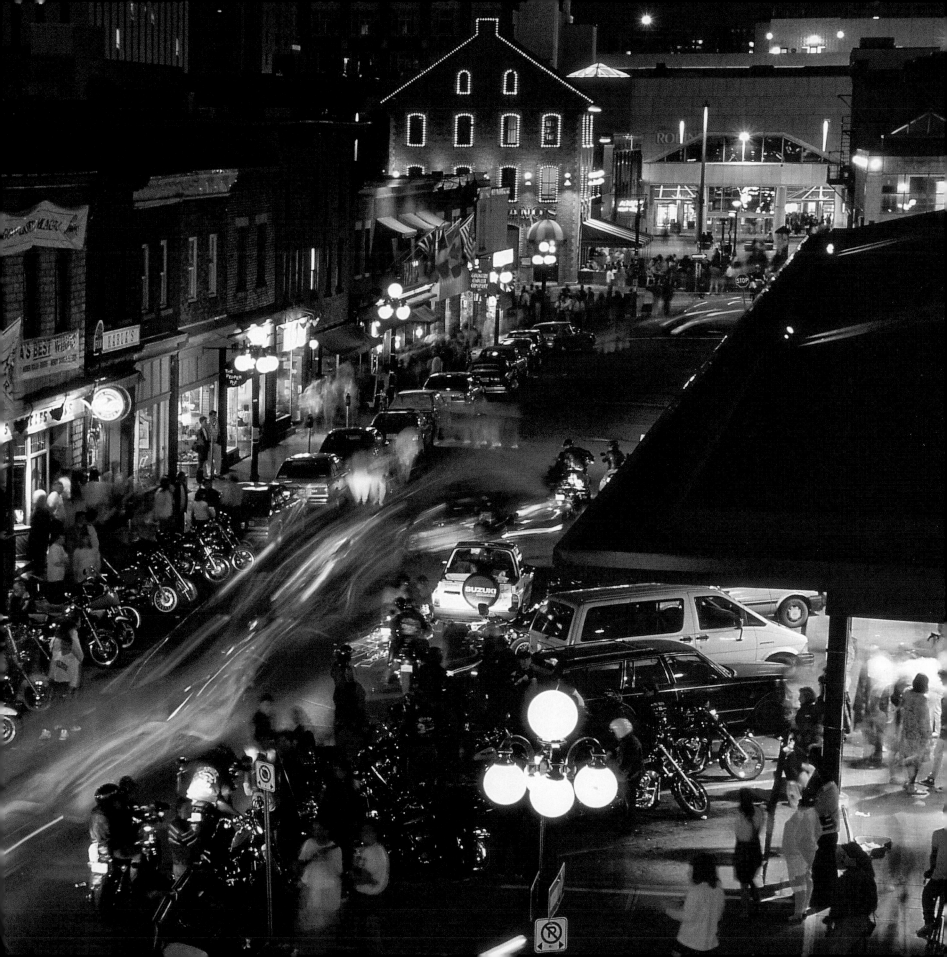

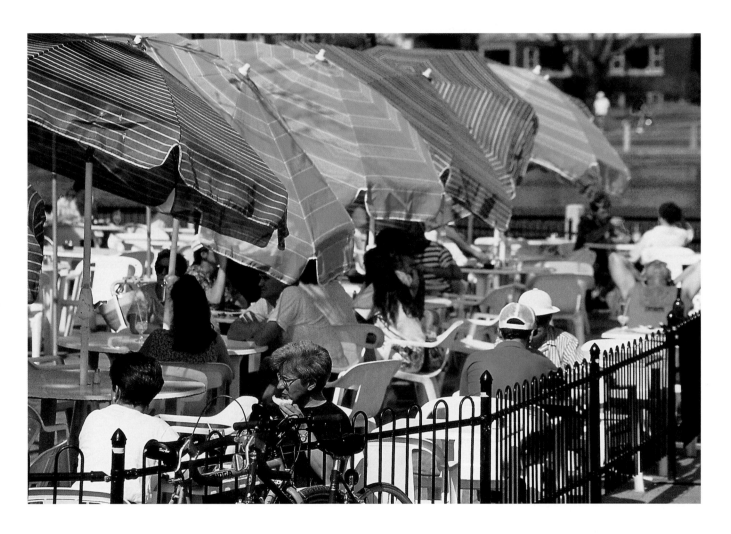

Tourists and business people mix at an outdoor café overlooking the Rideau Canal.

Since the 1830s, the market has offered fresh produce, flowers, crafts, and specialty foods throughout the week.

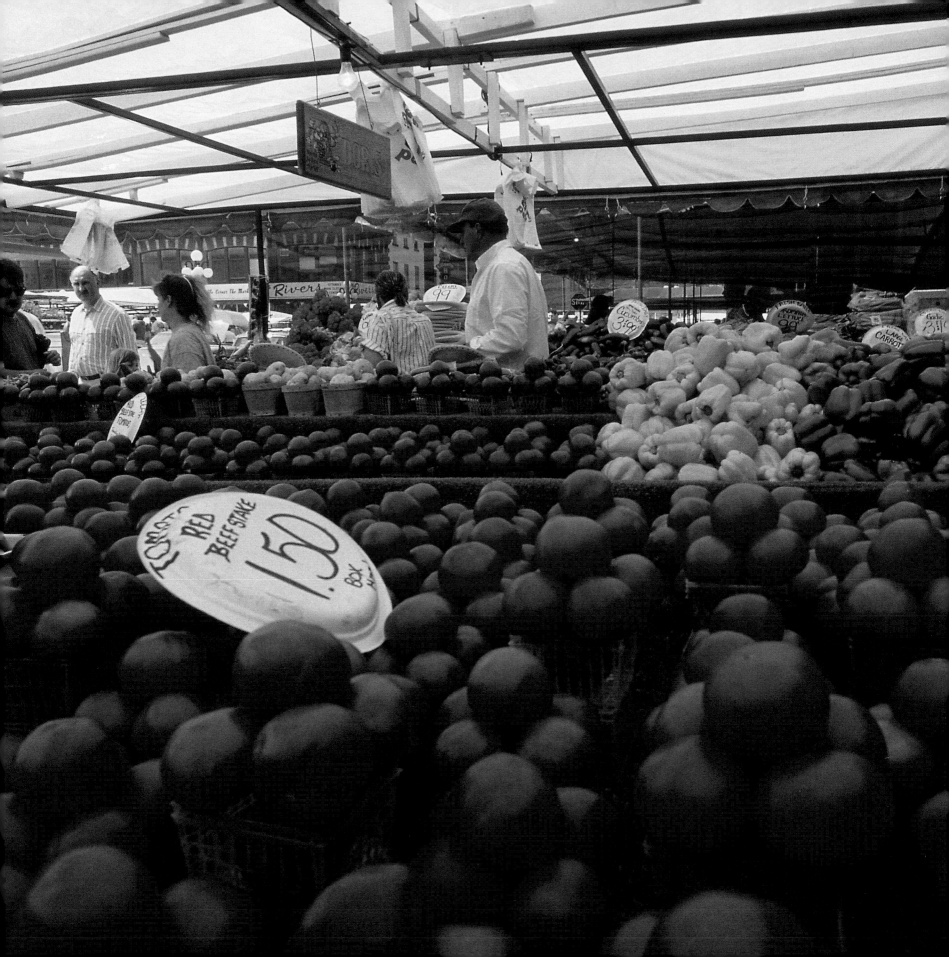

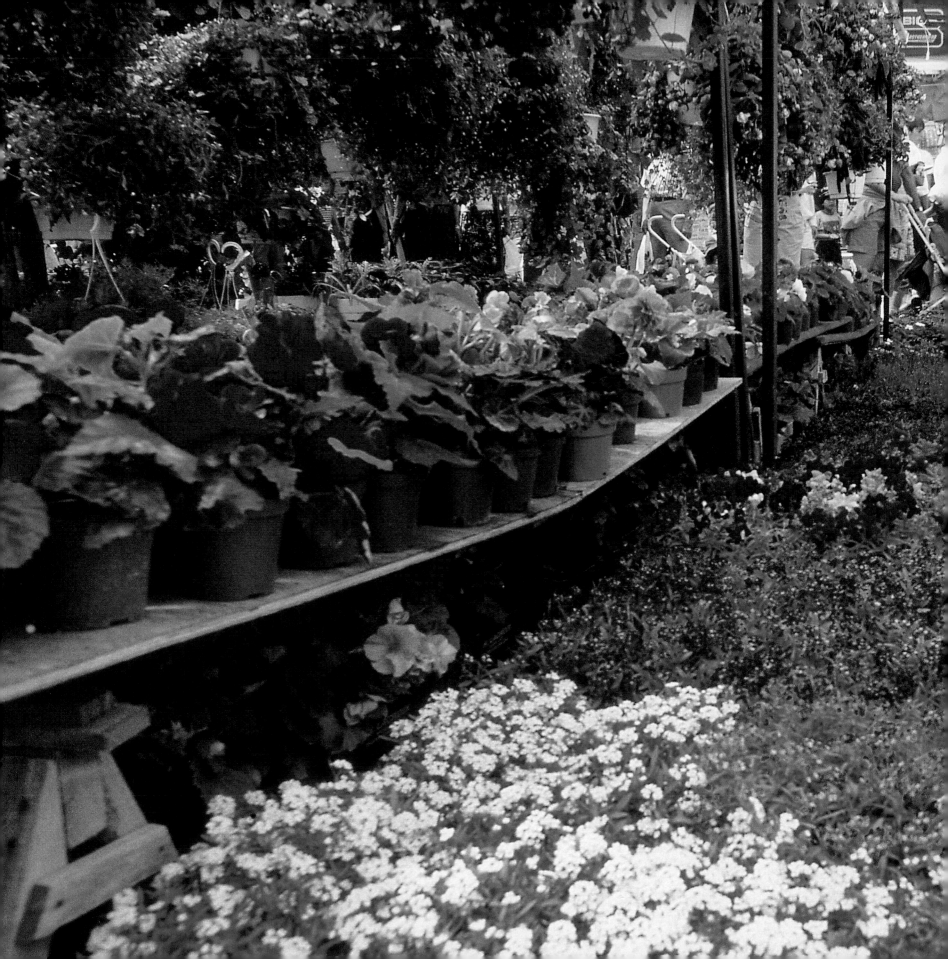

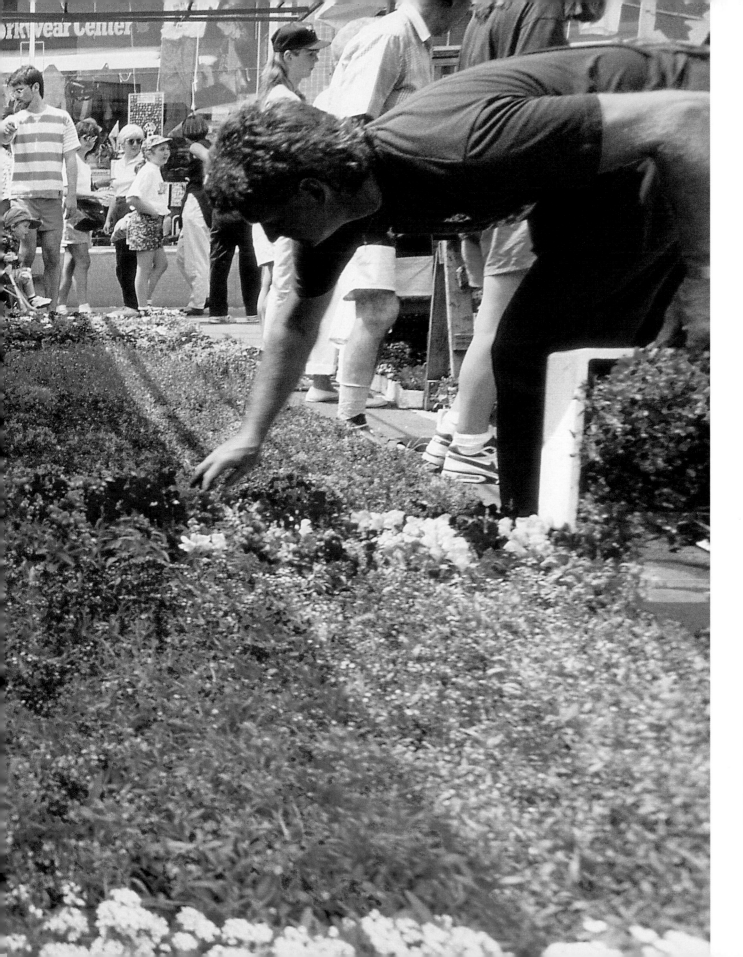

Byward Market is named for Lieutenant-Colonel John By, founder of Bytown, the settlement that later became Ottawa.

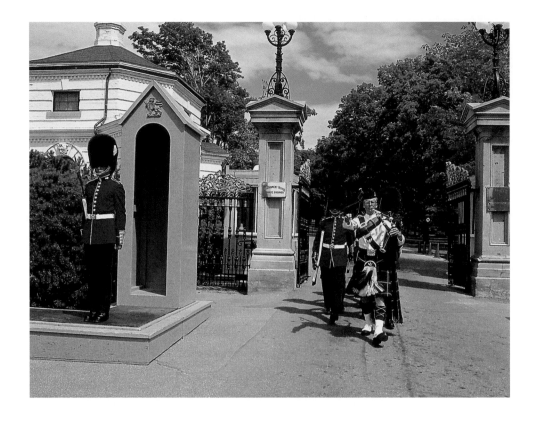

Sentries stand guard outside Rideau Hall, the residence of the governor general. The guards' ceremonial uniforms are based on those worn by nineteenth-century British troops in Africa.

Thomas MacKay built the Rideau Canal locks, city bridges, several mills, and a stone mansion which he christened Rideau Hall. In 1865, the mansion became the official residence of Canada's governor generals; the original eight-room home has since been expanded to include 60 rooms.

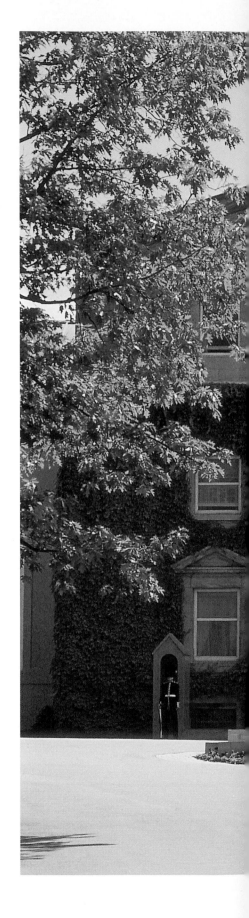

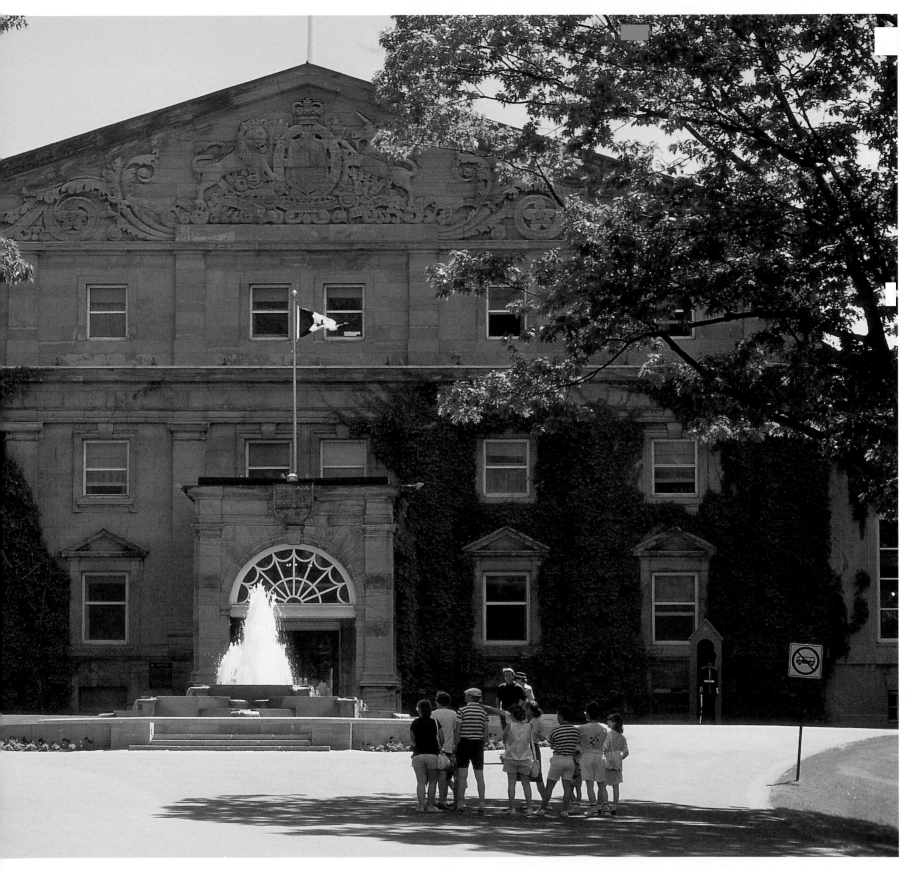

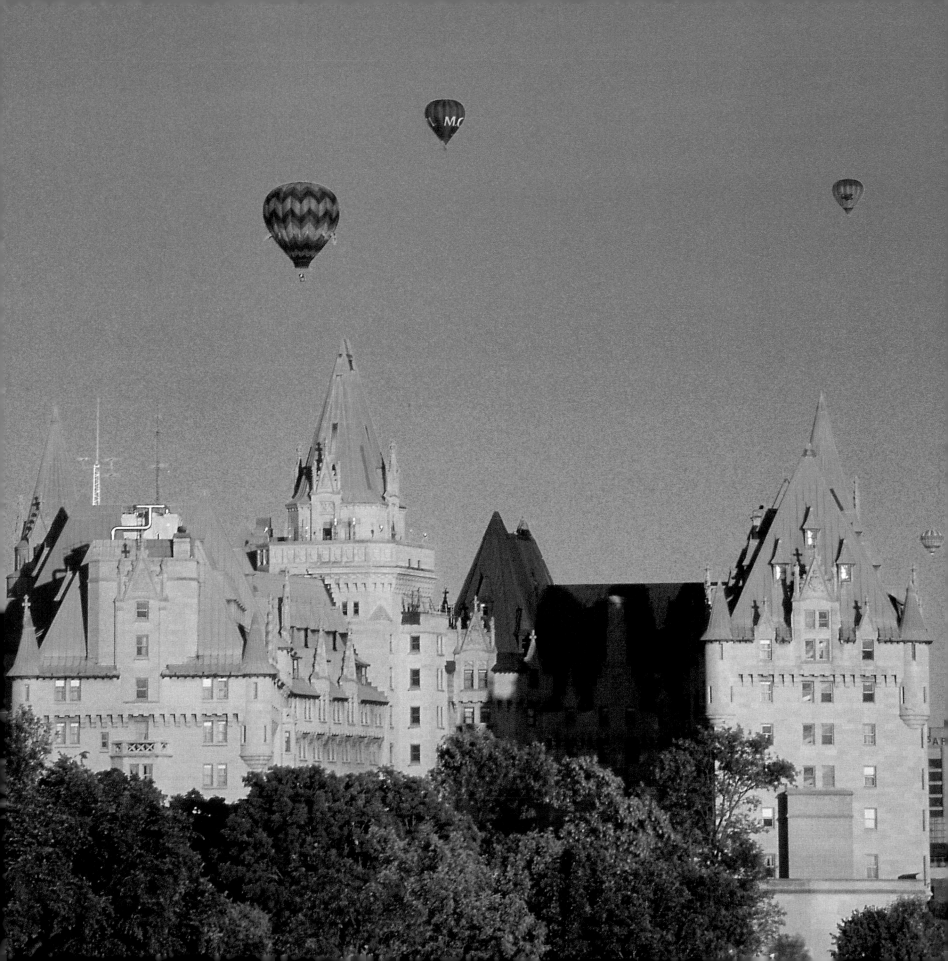

South of the city, walking and cycling paths wind over and around the canal.

On Labour Day weekend, 150 hot-air balloons lift off as part of the Gatineau Hot Air Balloon Festival. The festival began in 1987 and is now Canada's biggest balloon gathering.

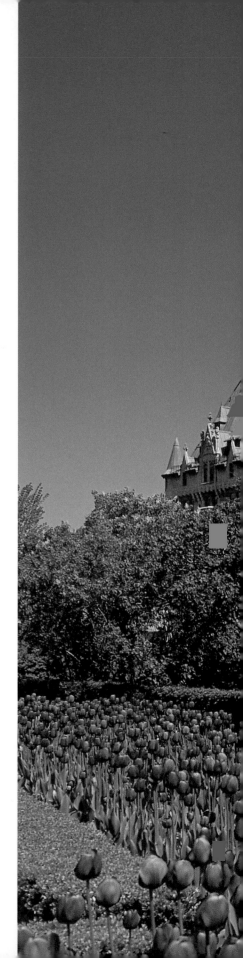

In Confederation Square, the National War Memorial honours more than 66,000 Canadians who died in World War I. It was created by British sculptor Vernon March. King George and Queen Elizabeth attended its unveiling in 1939.

OVERLEAF –
In traditional British uniforms and waving the Union Jack, mock troops re-enact a battle from the War of 1812, complete with musket and cannon fire.

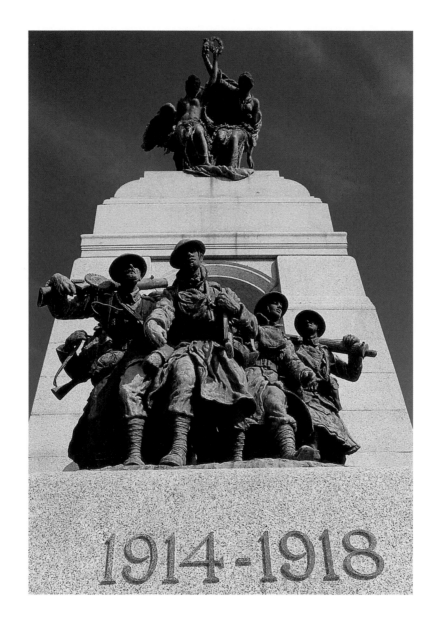

1914-1918

One of Canada's most prominent hotels, the Chateau Laurier, was built in 1912 by Canadian Pacific Railway, the same company that built Victoria's Empress Hotel and the Chateau Lake Louise.

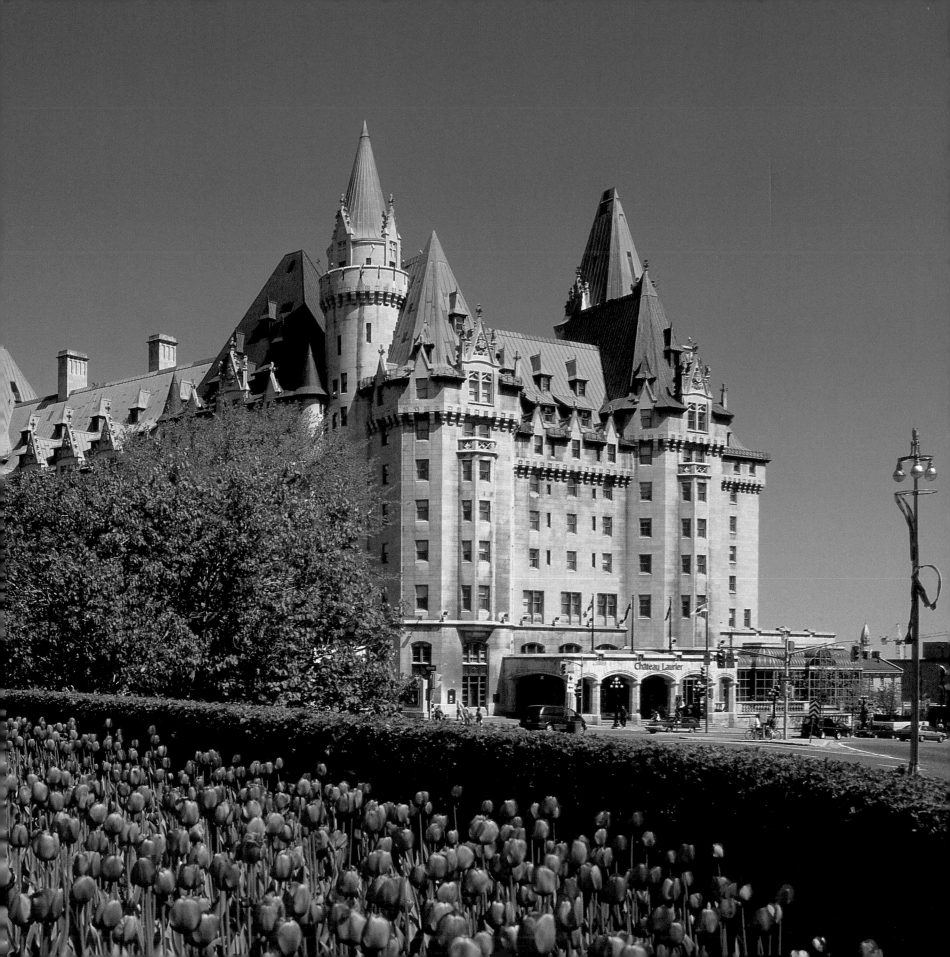

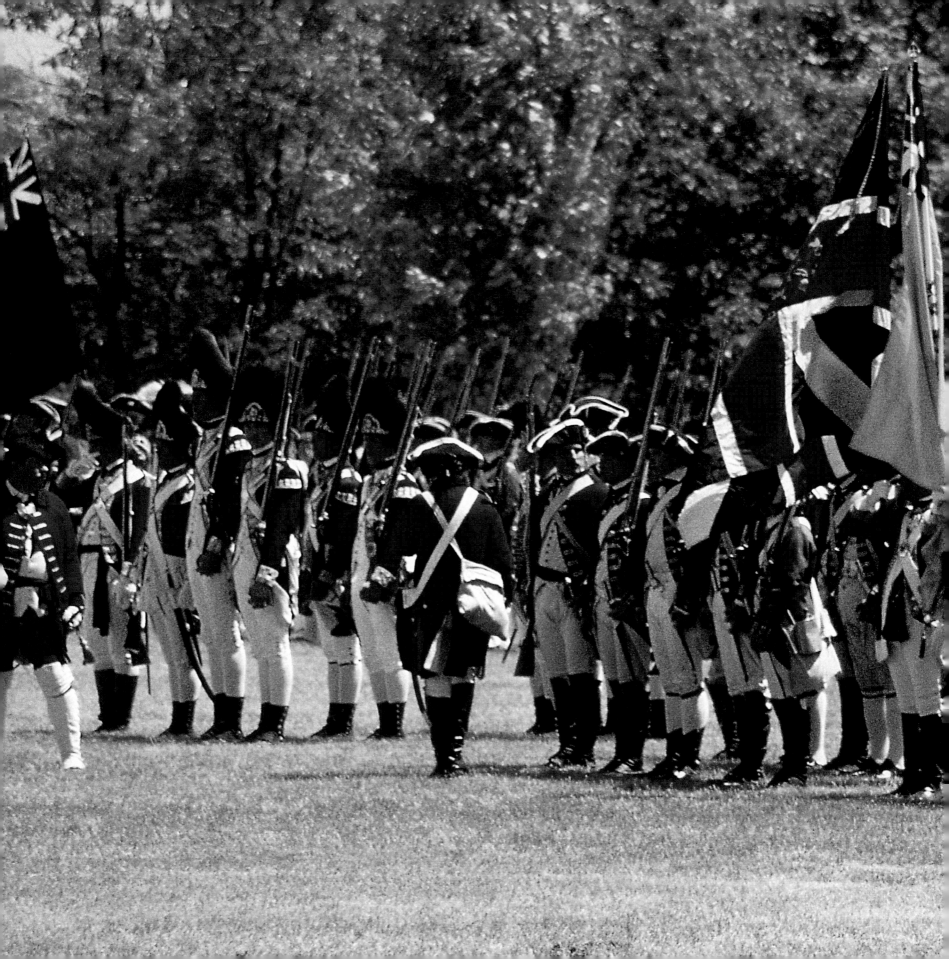

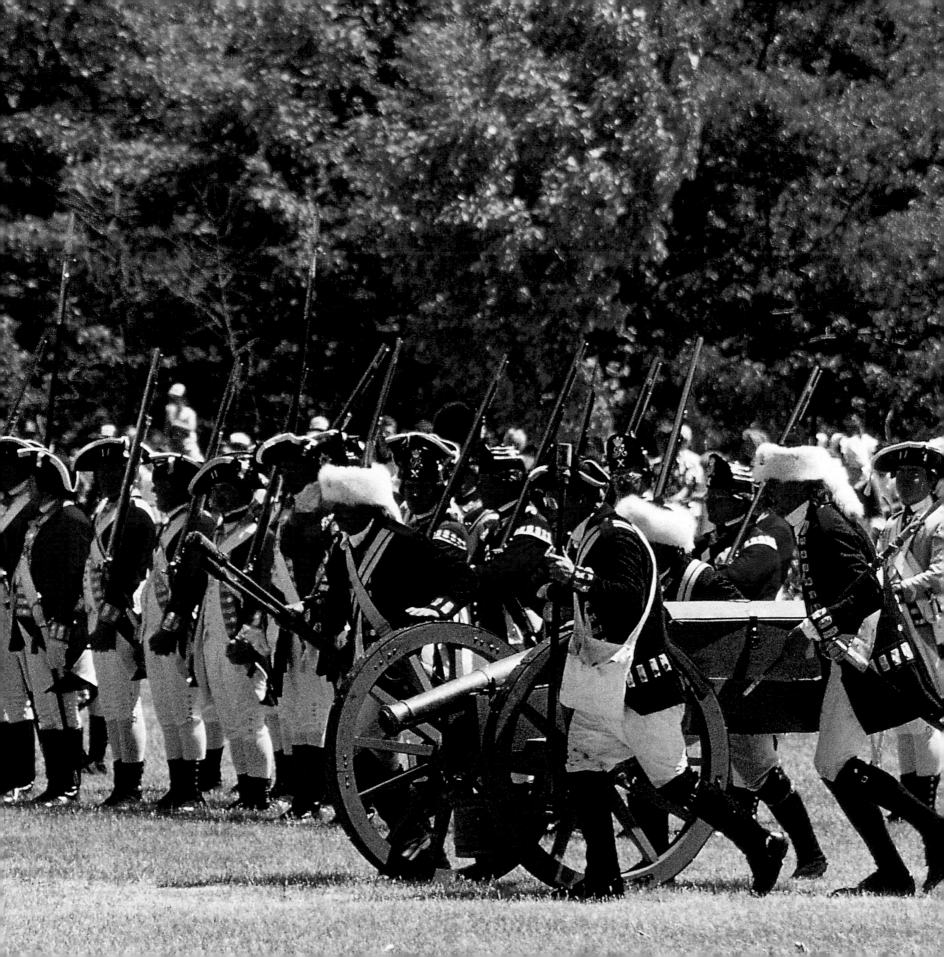

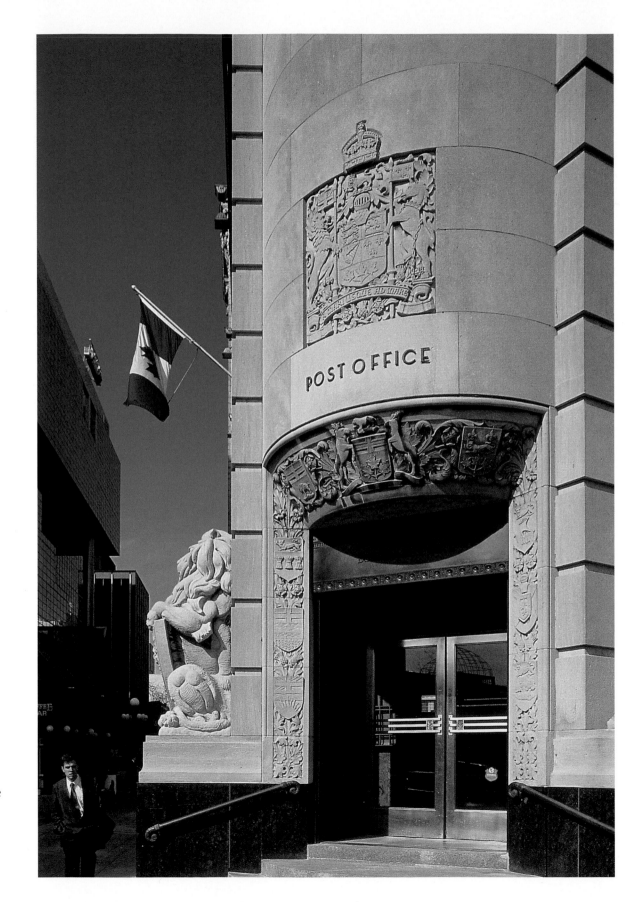

The stately post office building is more than a century old.

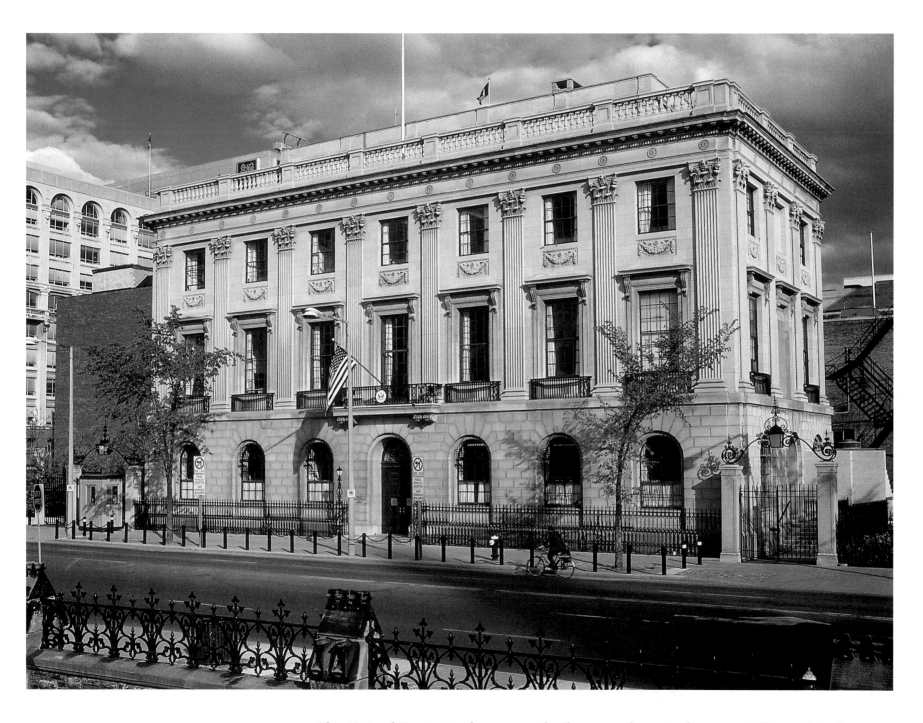

The United States Embassy was built across from Parliament Hill in 1932. The two countries share the longest undefended border in the world and United States is Canada's largest trading partner.

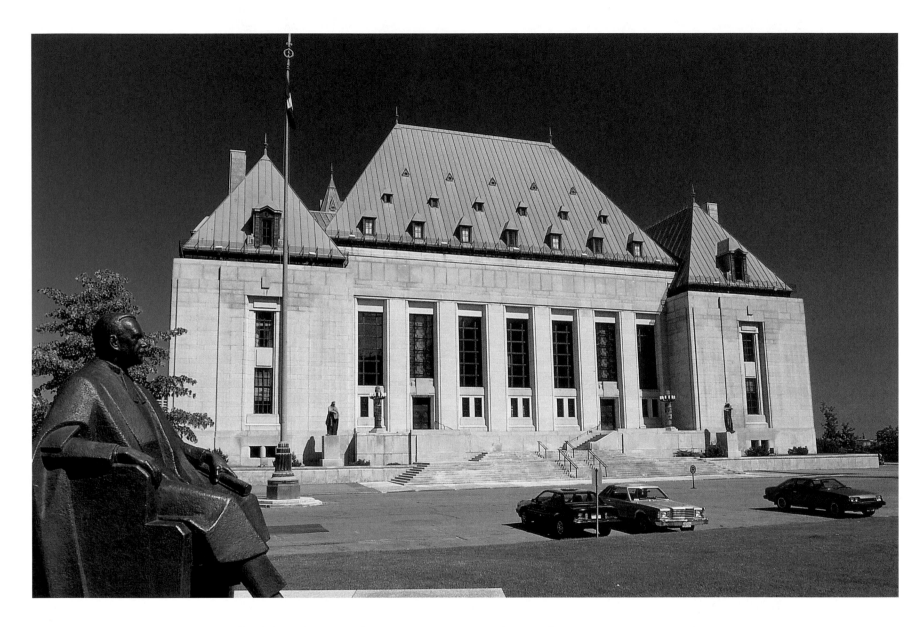

This imposing art deco–style building houses the Supreme Court of Canada. The building was begun in 1939, delayed by the outbreak of World War II, and completed in 1946.

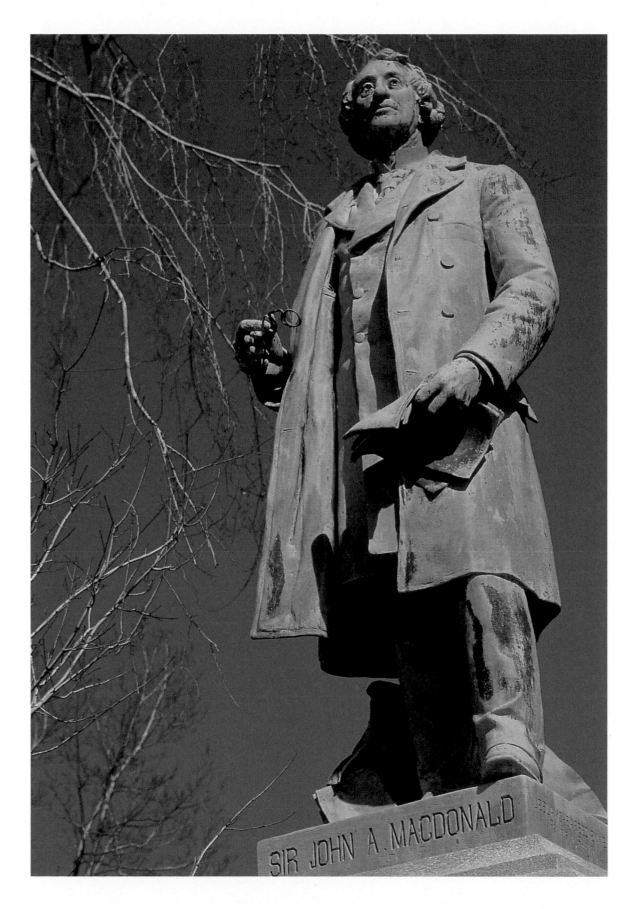

Lawyer, land speculator, and Canada's first prime minister, Sir John A. Macdonald led the government during a time of controversy over the official languages, the building of the transcontinental railway, the national policy on foreign trade, and several rebellions.

This personification of truth stands outside the Supreme Court.

FACING PAGE –
The Supreme Court's marble entrance hall is 12 metres high. The lawyers conferring in the centre have a lot at stake: because this is Canada's highest court of appeal, the decisions of the nine judges are final.

OVERLEAF –
Tour boats offer excursions along the calm waters of the Rideau Canal. Visitors can view the Parliament Buildings, the prime minister's residence, and the Chateau Laurier.

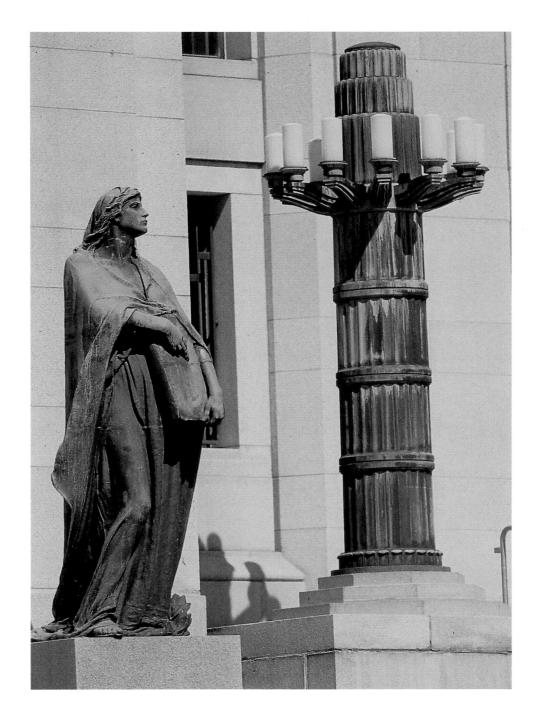

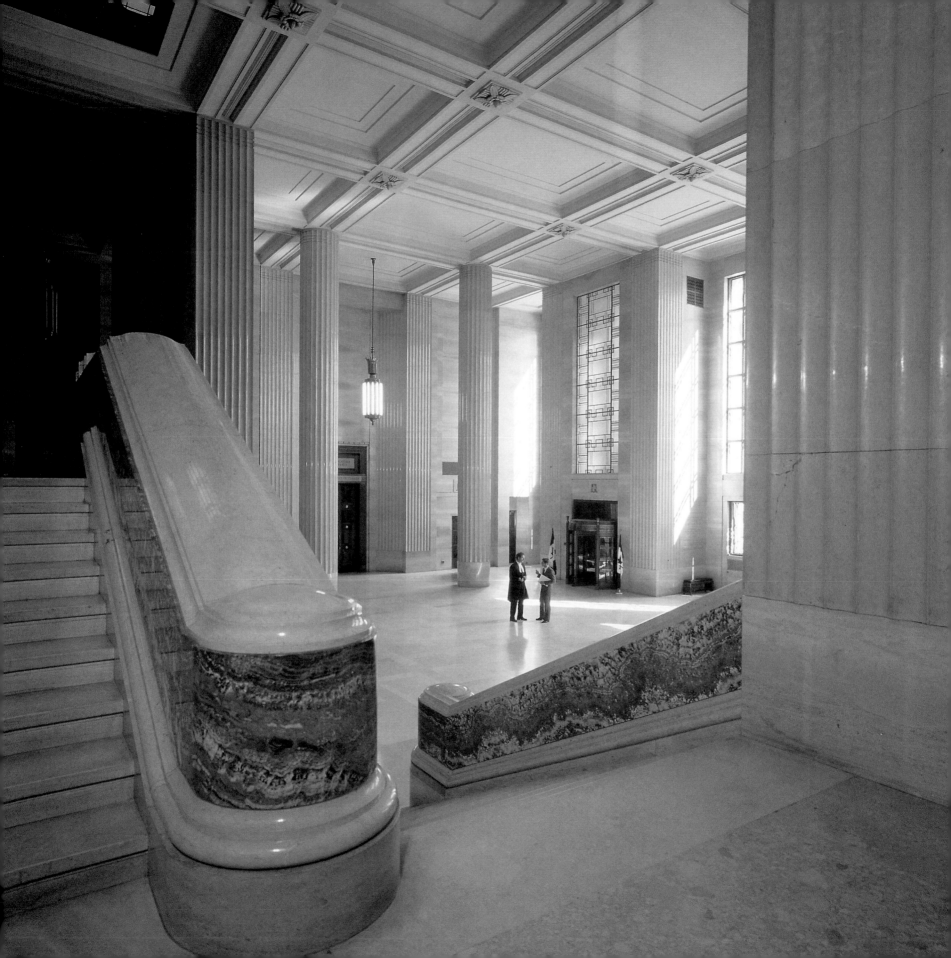

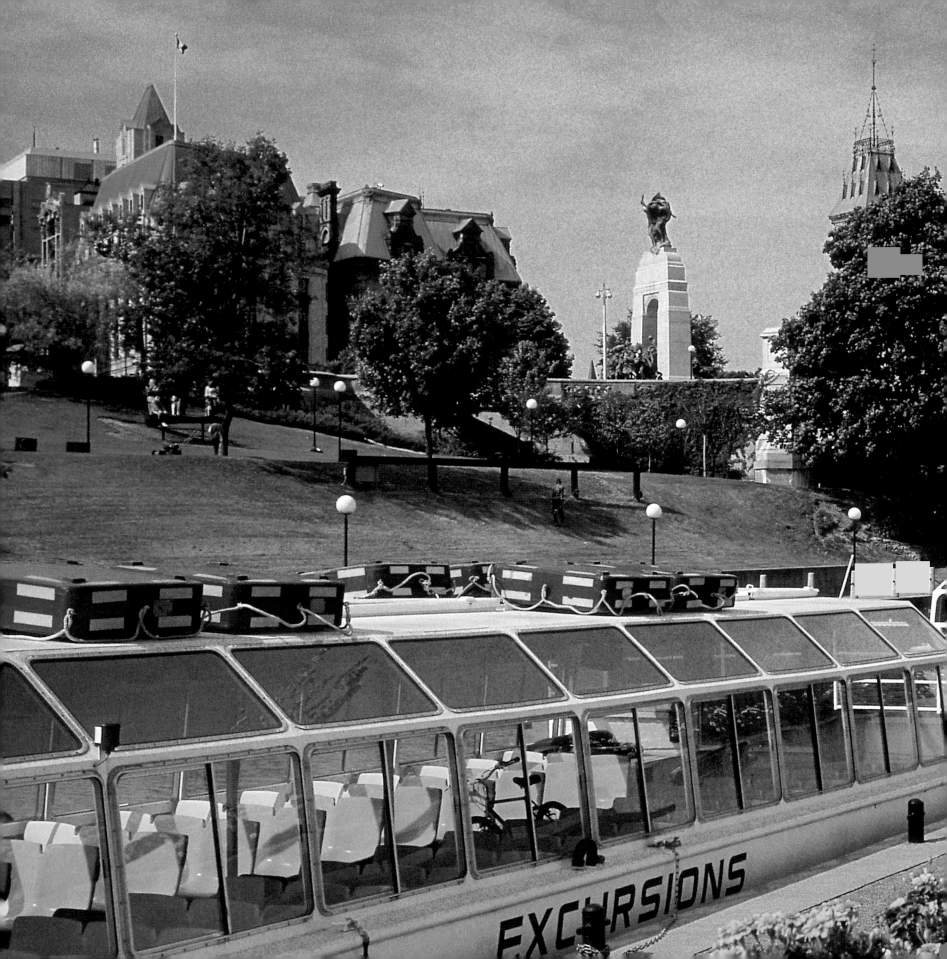

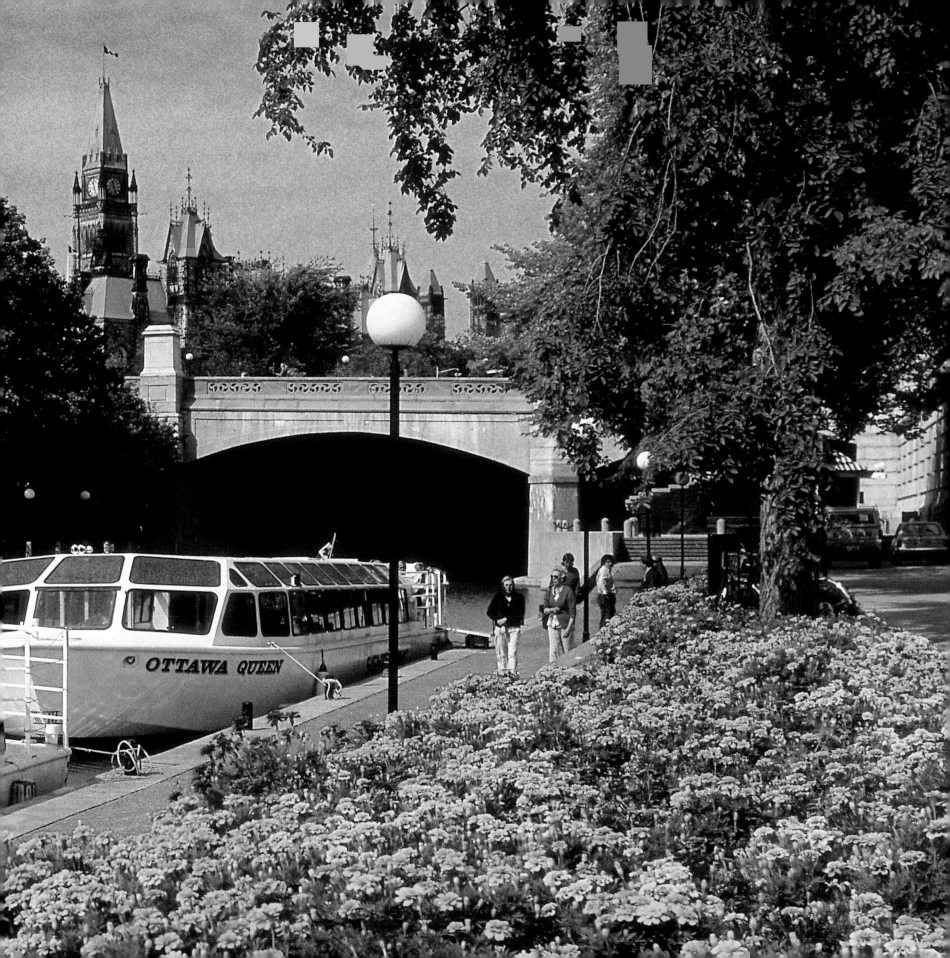

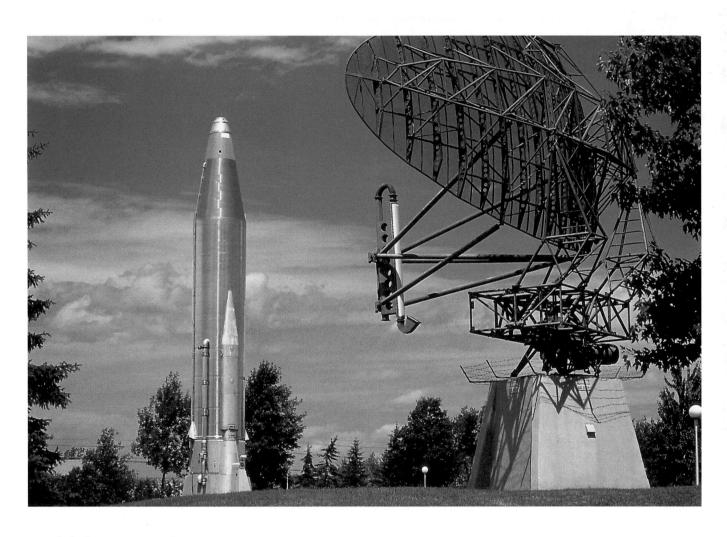

Model ships, steam locomotives, printing presses, space equipment, and computers—games, displays, and hands-on activities at the National Museum of Science and Technology lead visitors on a journey of discovery.

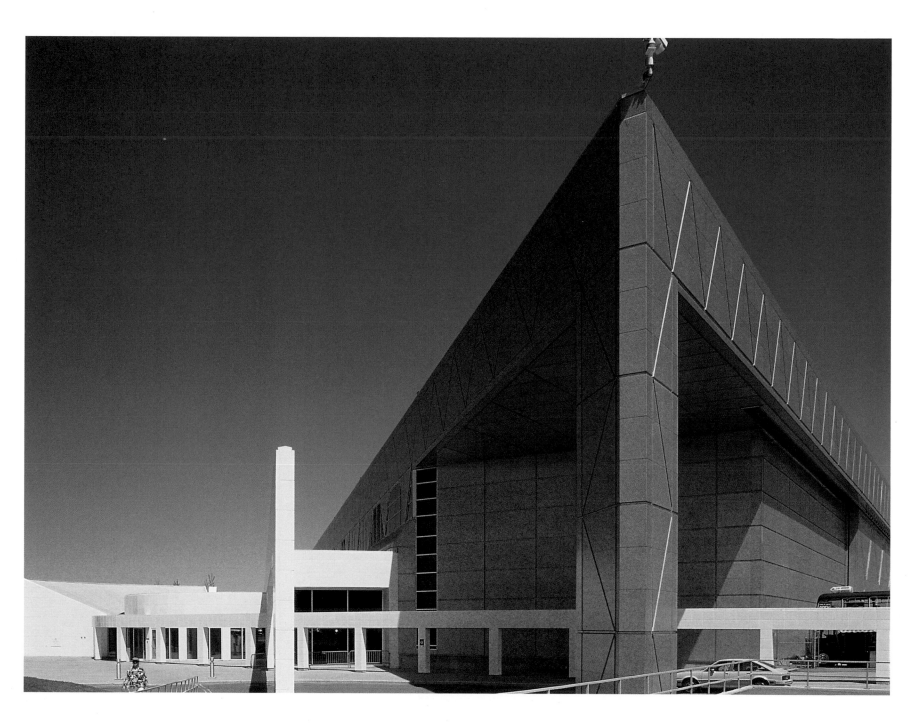

With its modern, aerodynamic shape, the National Aviation Museum seems ready to take flight at any moment. More than three football fields could fit inside.

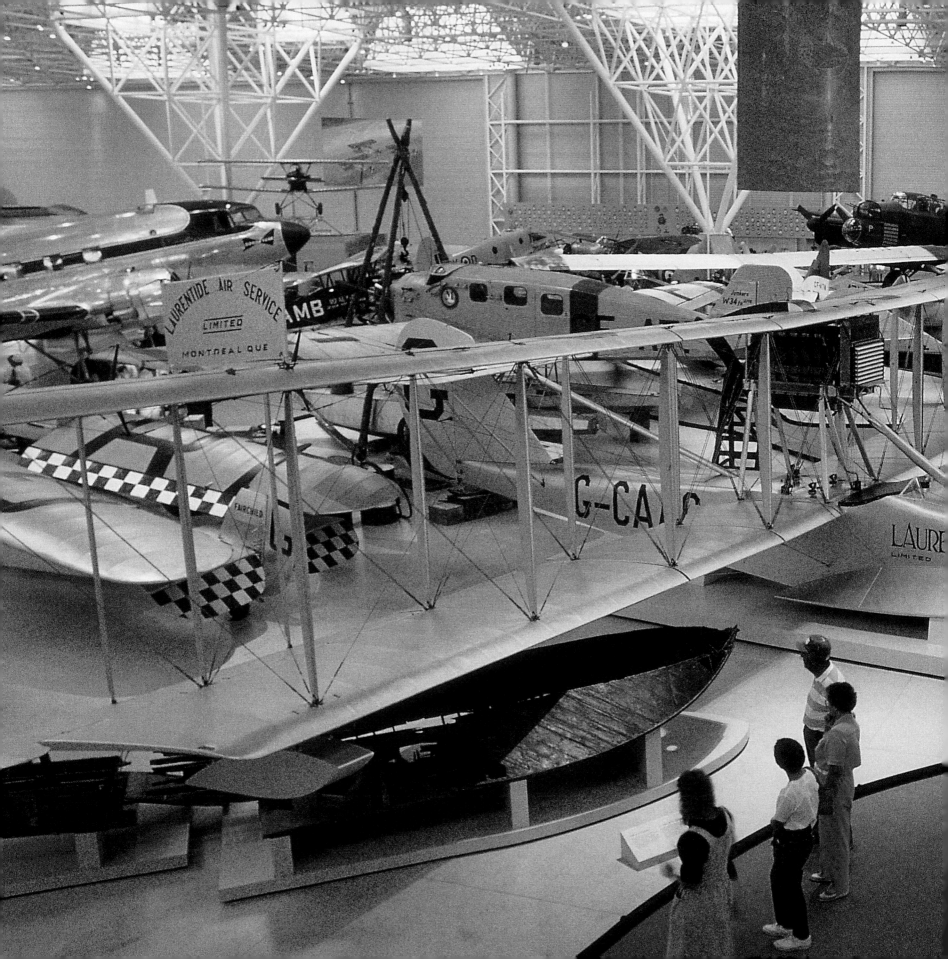

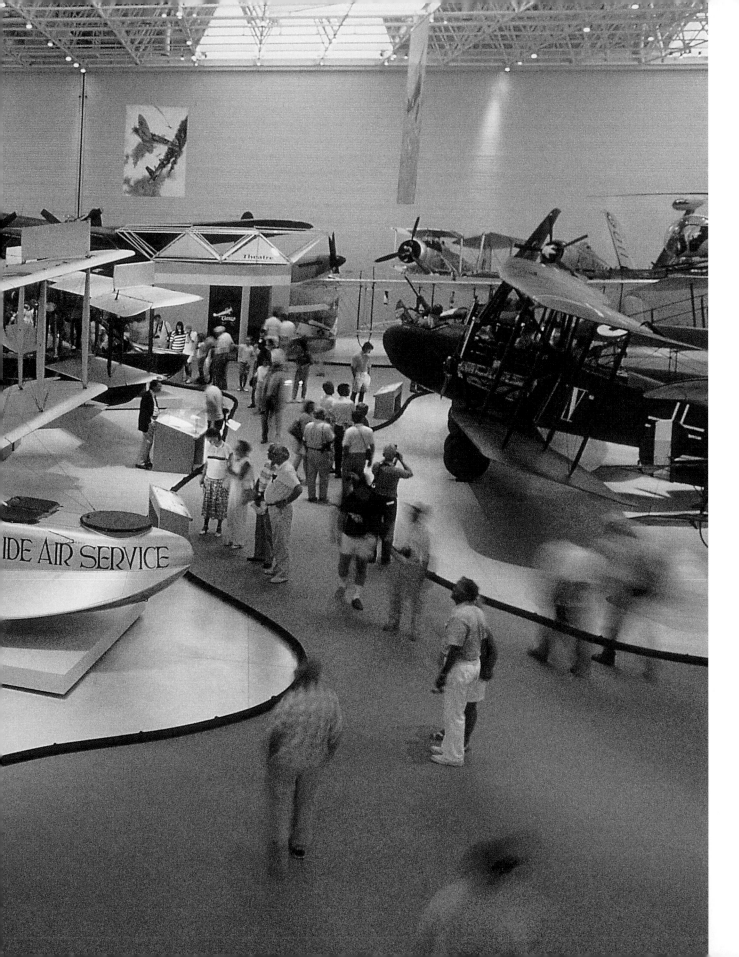

The National Aviation Museum features more than 100 aircraft, including a replica of the plane that made the first powered flight in Canada, military bombers, and modern jets.

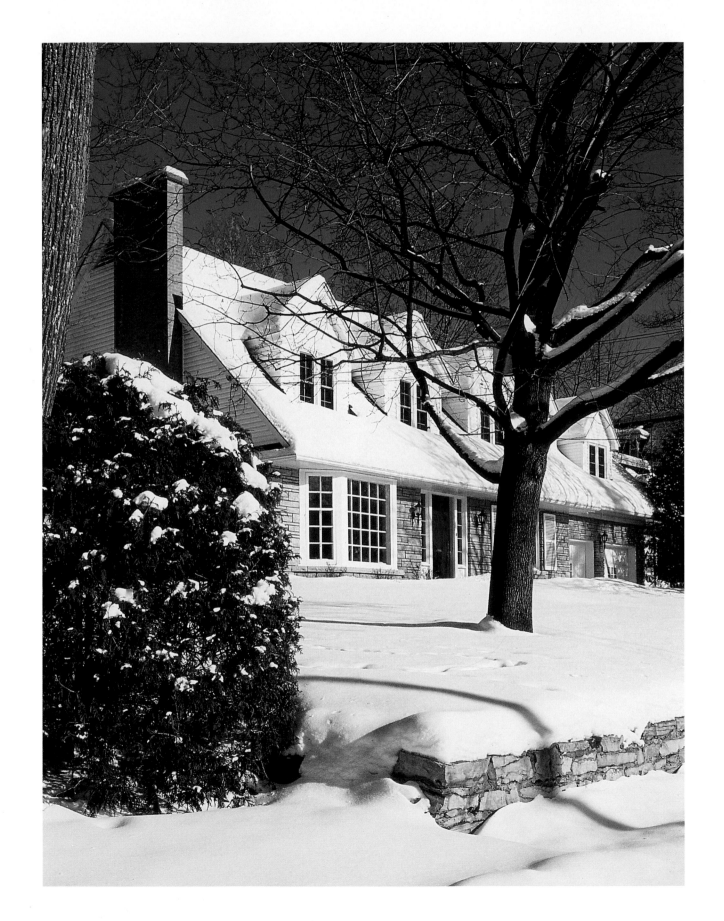

Fresh snowfall turns Rockcliffe's Buena Vista Road into a picturesque winter paradise. This is the area near the city where many ambassadors reside.

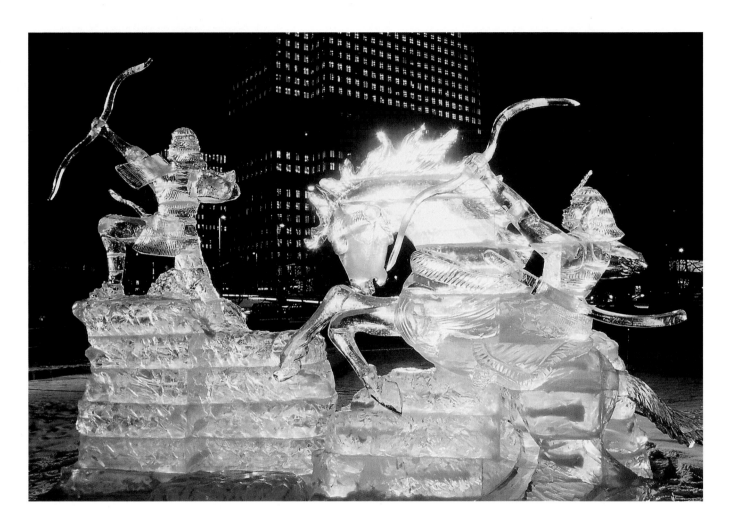

Brightly lit ice sculptures adorn the city during Winterlude,
a festival held on three consecutive weekends each February.
The festival includes more than 100 outdoor activities and
attracts more than a million visitors.

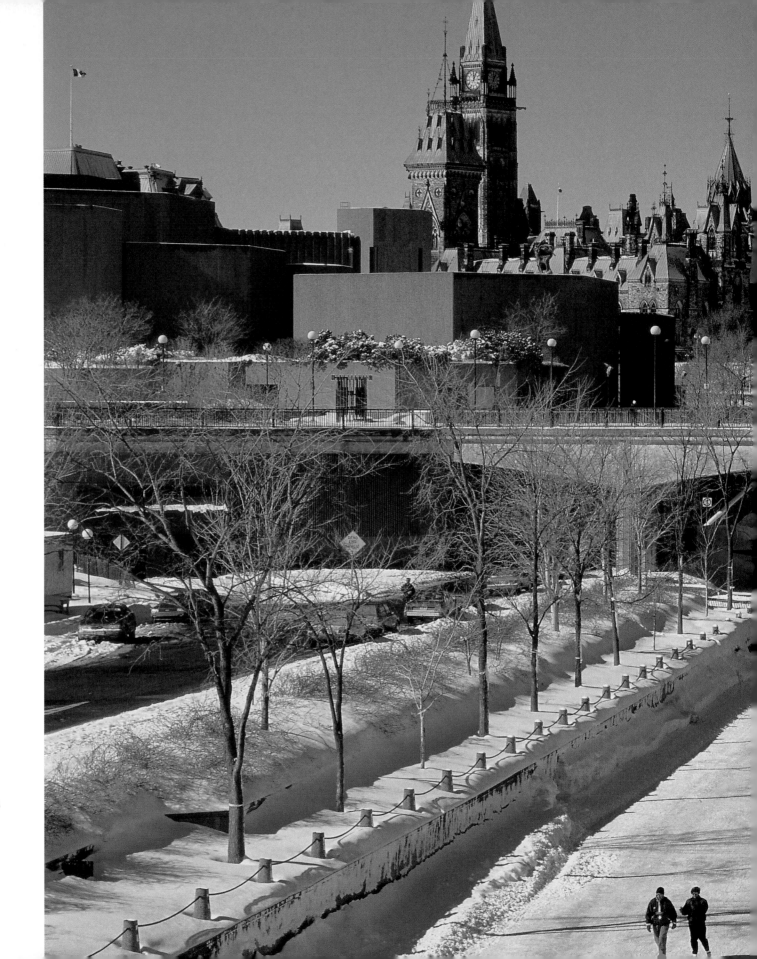

In winter the Rideau Canal is transformed into the world's longest skating rink, with eight kilometres of cleared and maintained ice.

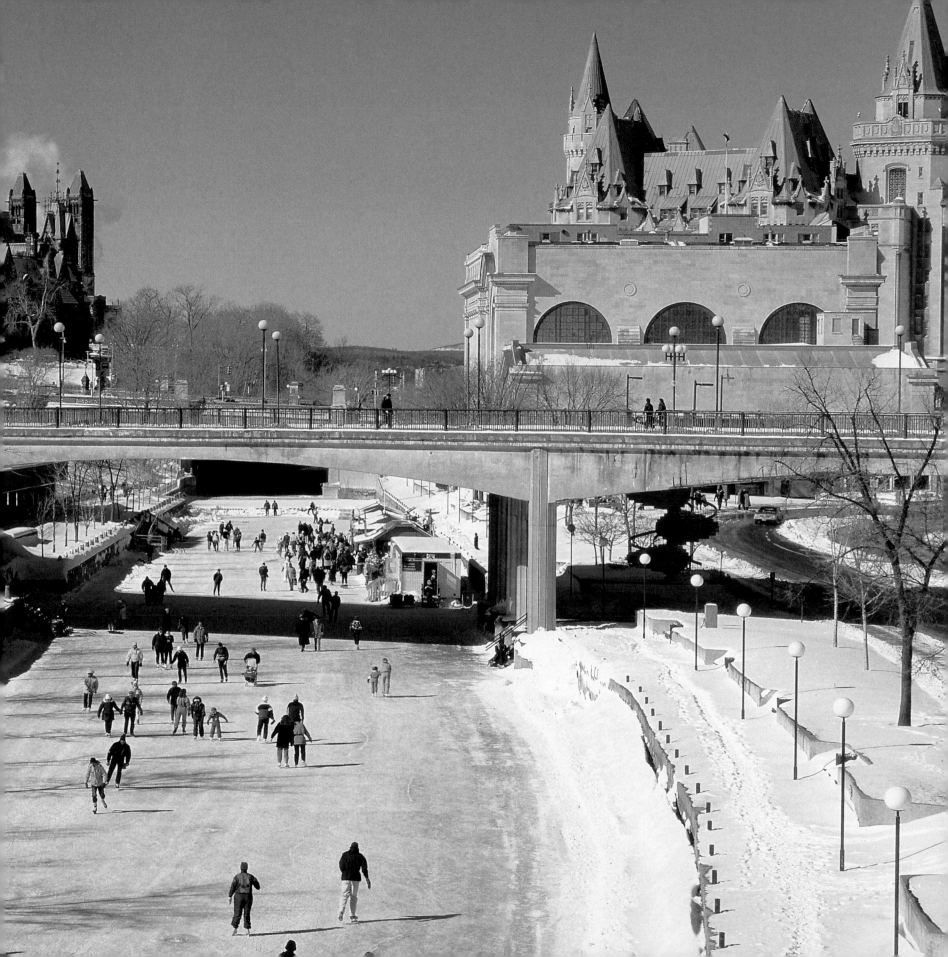

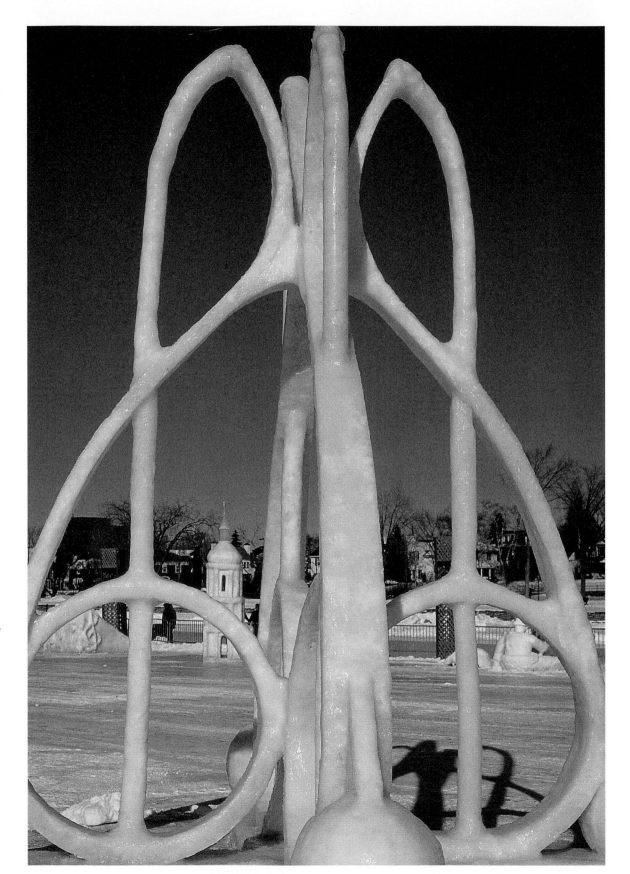

This is not an ice carving but a snow sculpture, a completely separate event in the Winterlude festivities.

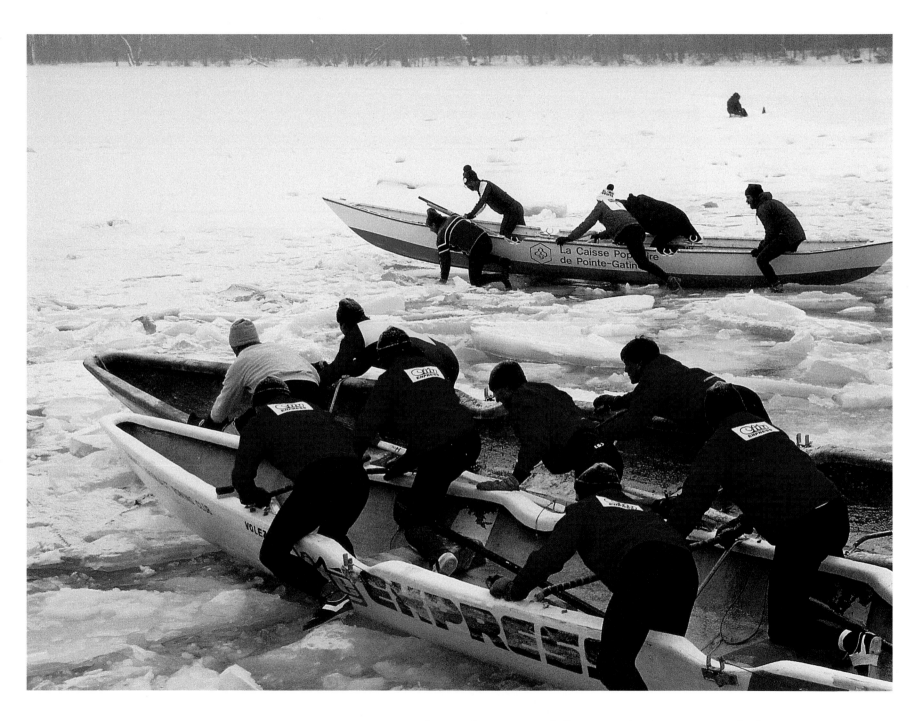

Who said winter is dull? Winterlude events include canoe races, a skate-a-thon, sculpting competitions, and musical performances.

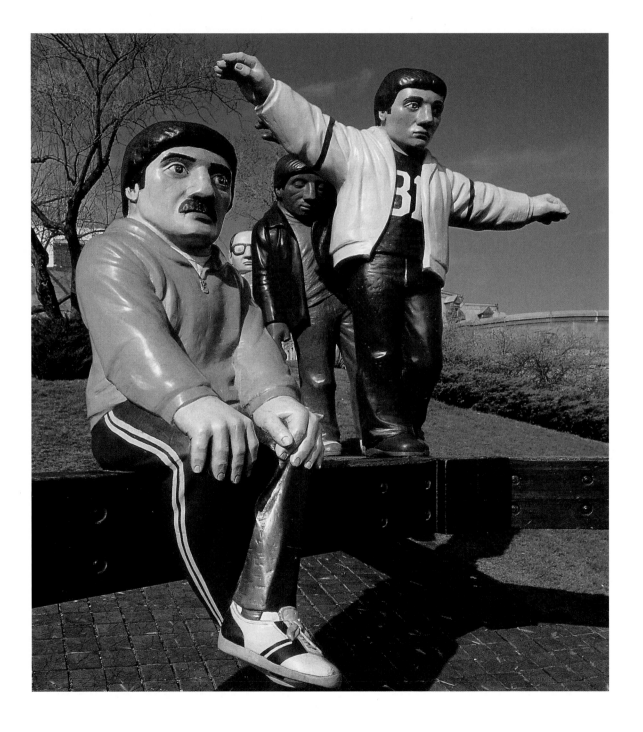

Balancing, by New Brunswick sculptor John Hooper, stands on the grounds of the National Arts Centre. The figures are intentionally placed low to the ground, where visitors can examine them. They were created to reflect the wide array of activities offered in and around the centre.

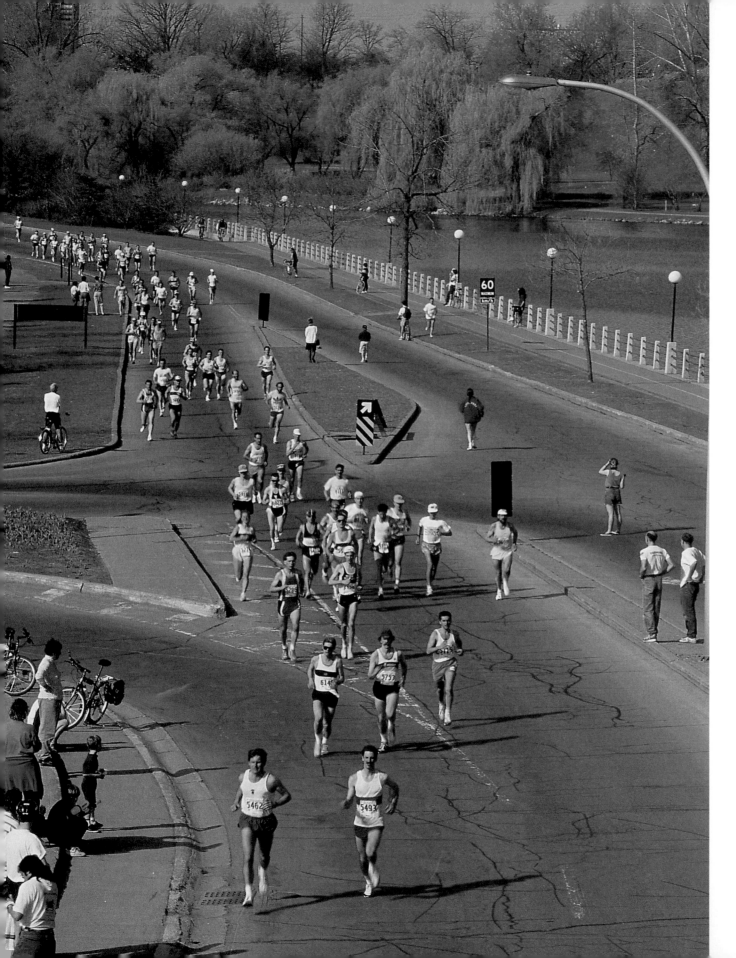

One of the most popular runs in Canada, the National Capital Marathon in May follows a scenic out-and-back course through the city's streets and parks.

This building was briefly the home of the government after the Parliament Buildings burned in 1916. Now, the mammoth outside marks it as the Canadian Museum of Nature, featuring Alberta dinosaurs, an array of stuffed birds and animals, and some spectacularly large gems.

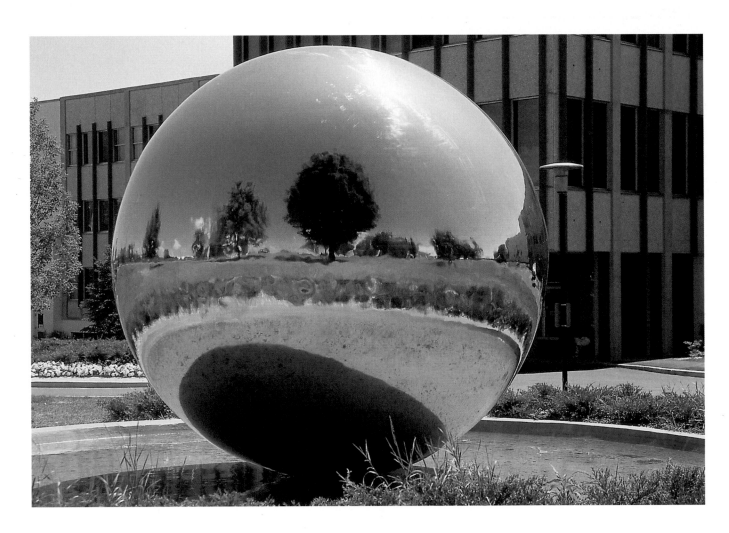

A reflecting ball stands outside the National Research Council of Canada, a crown corporation instrumental in funding, conducting, and collecting scientific research. The council also represents Canada in a number of international research projects.

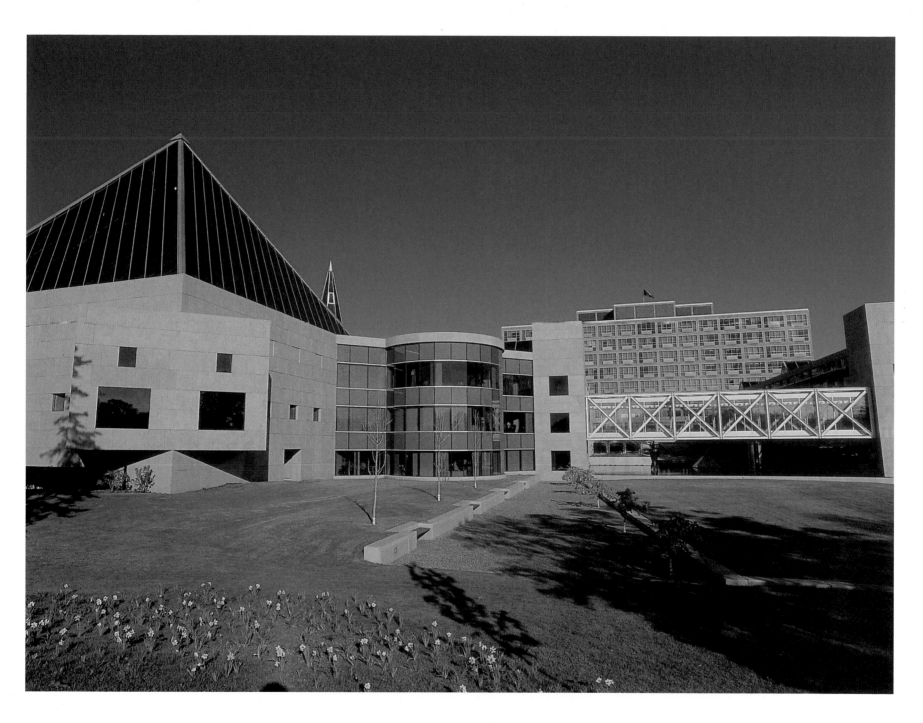

As a seat of government, it's hard to compete with the Parliament Buildings, but City Hall strikes a modern architectural contrast. It stands on Green Island in Rideau River.

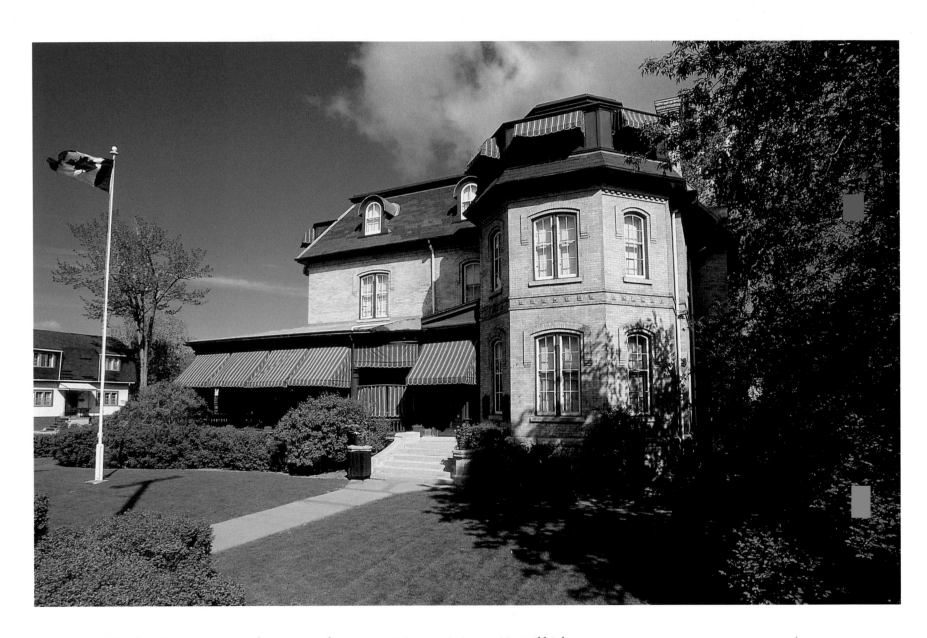

Built in 1878, this Victorian residence was home to Prime Minister Sir Wilfrid Laurier until his death in 1919, when his widow offered it to one of Canada's most charismatic and controversial prime ministers, William Lyon Mackenzie King. The home is now open to the public and features some of the original furniture of the Laurier family.

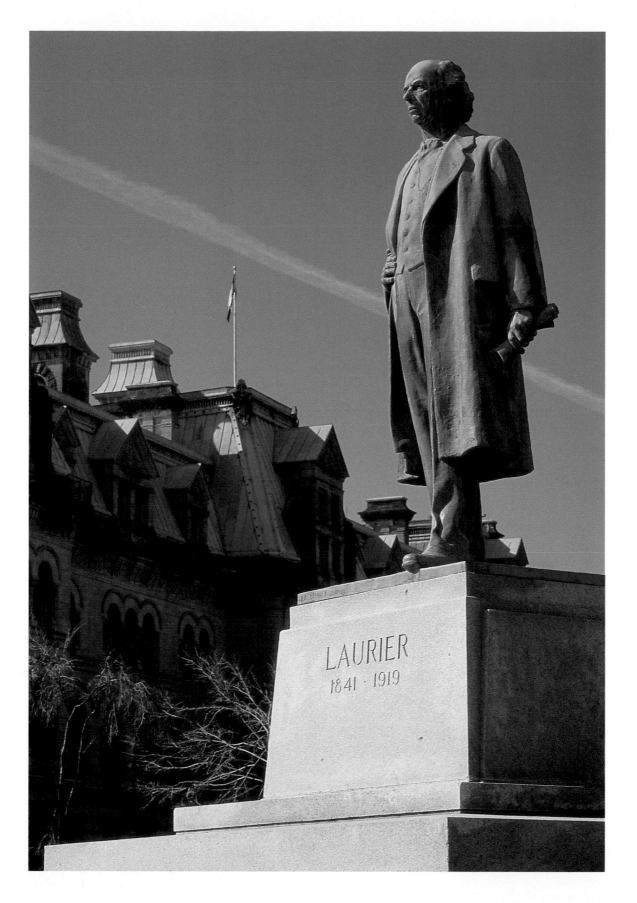

Canada's first French-speaking prime minister, Sir Wilfrid Laurier, led the Liberal Party from 1887 until his death in 1919.

The Sparks Street Mall is filled with shops, food stands, rock gardens, sculptures, fountains, and cafés. It was opened as a summer pedestrian walk in 1963 and was so successful that it was opened year-round in 1966.

55

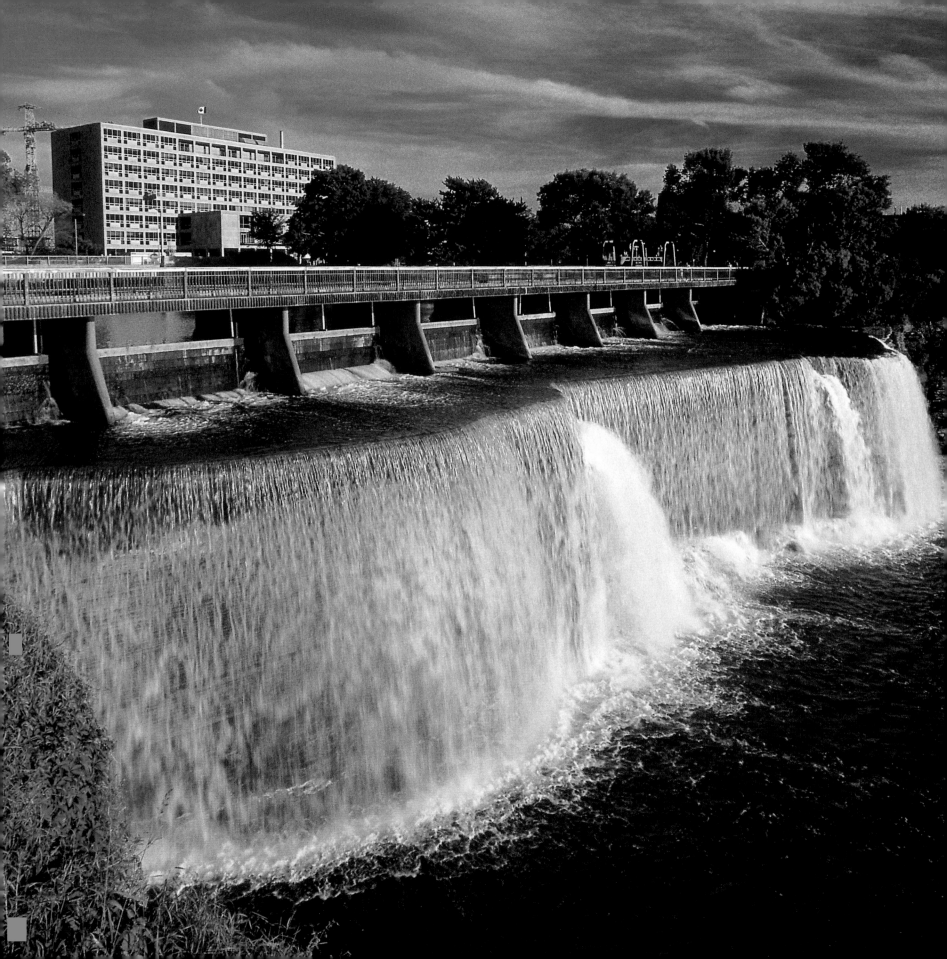

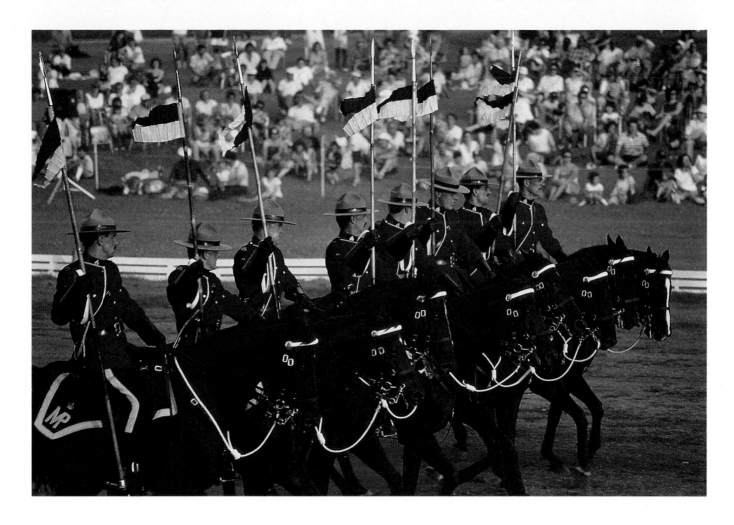

The Royal Canadian Mounted Police Musical Ride stemmed from the drill training of the police force in the nineteenth century. The Mounties perform in Ottawa each evening during the week before Canada Day.

OVERLEAF –
More than 200 types of tulips bloom in Ottawa each spring. Most are gifts from Holland in gratitude for Canada's hospitality to the Dutch royal family during World War II. Because the royal family must be born on Dutch soil, the Canadian hospital room where Princess Margriet was born was declared part of the Netherlands.

These twin falls were named Rideau, meaning "curtain," by French fur traders in the seventeenth century. Before the falls were preserved as parkland, they were used to power mills, foundries, and breweries along the river.

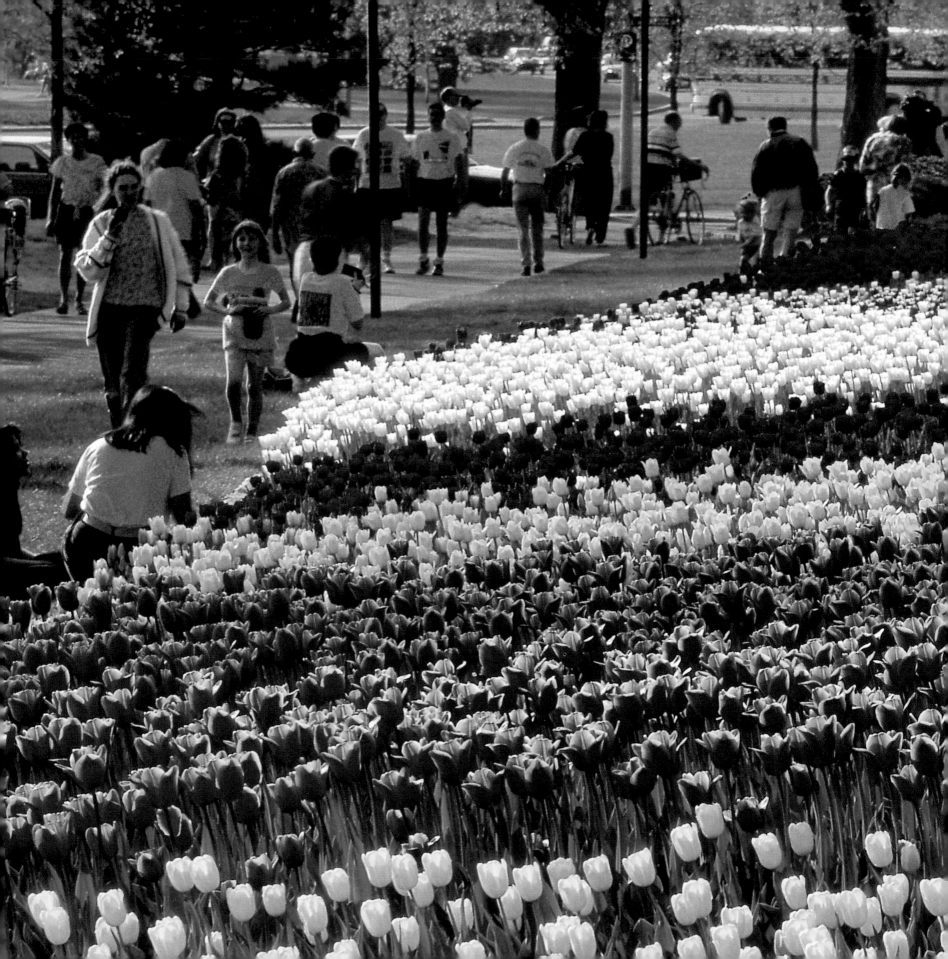

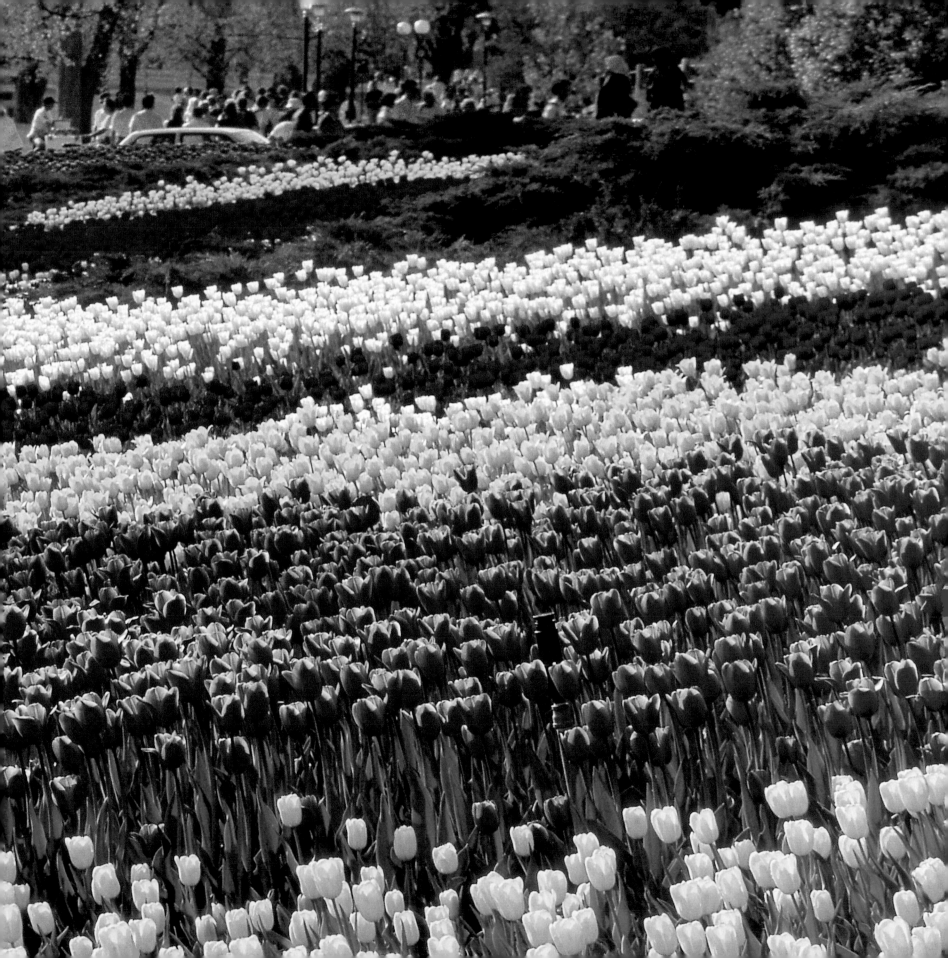

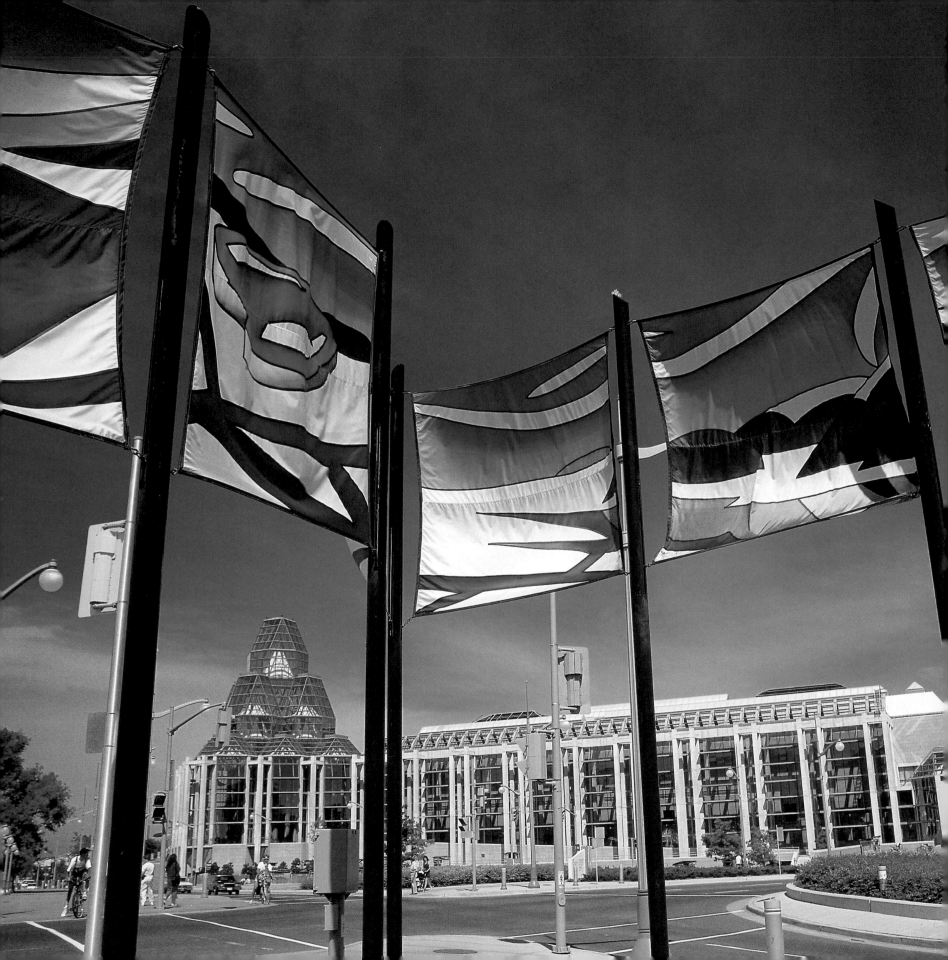

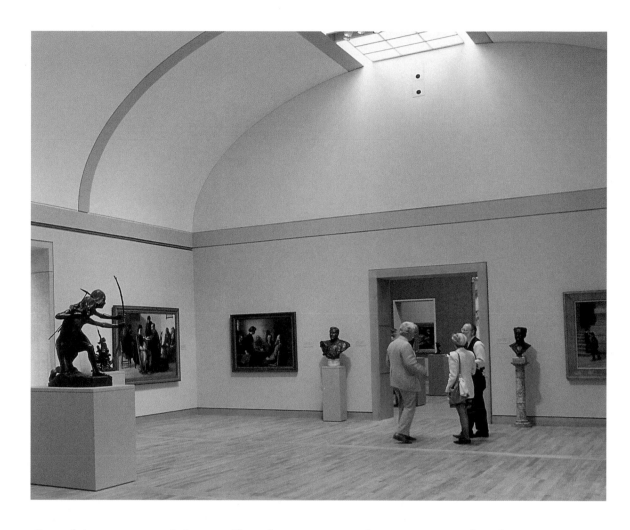

Canada's most prestigious gallery houses more than 45,000 works of art. It is known for its extensive collection of Canadian art, including paintings by the Group of Seven and a wide array of Inuit sculptures and prints. There are also works by international artists, such as Monet, Cézanne, and Picasso, on display.

The National Gallery was designed in 1988 by Moshe Safdie, the same architect who designed the Vancouver Library and Quebec City's Musée de la Civilisation.

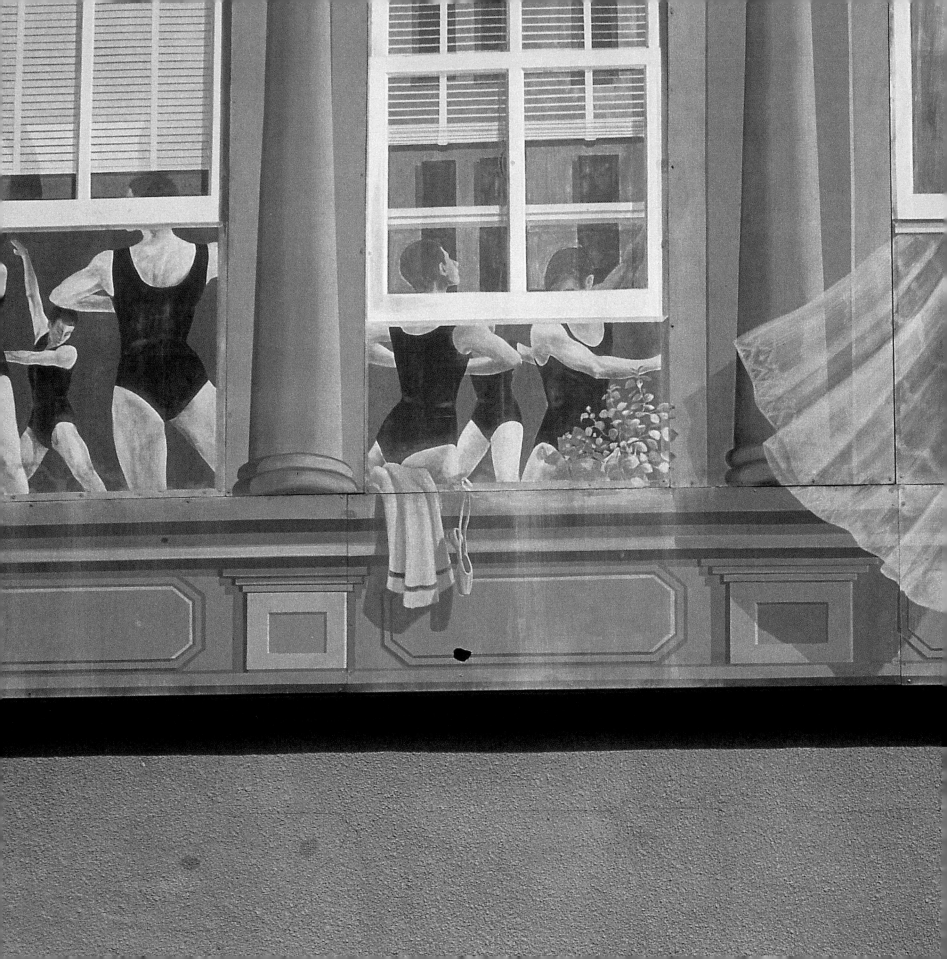

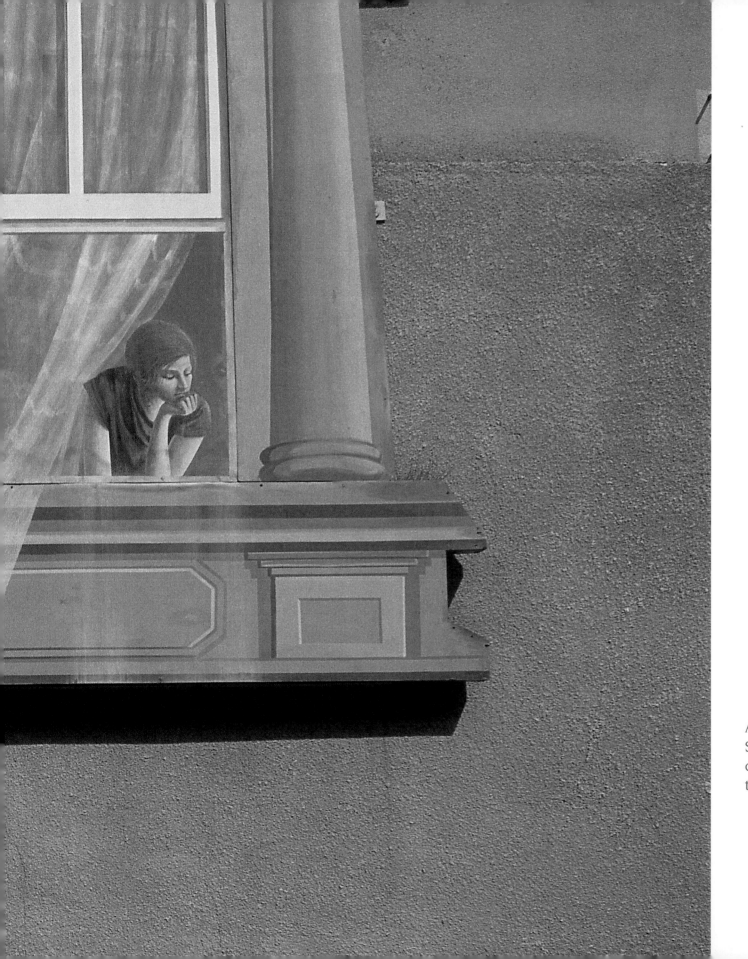

A clever mural in the Sparks Street Mall causes many double-takes.

Many of Ottawa's landmarks line Sussex Drive: the National Gallery, Notre Dame Basilica, the Royal Canadian Mint, and the prime minister's residence.

Almost invisible from the street, the prime minister's residence at 24 Sussex Drive towers over the Ottawa River. The mansion was built by a local lumber baron in 1867 and purchased by the government in 1949.

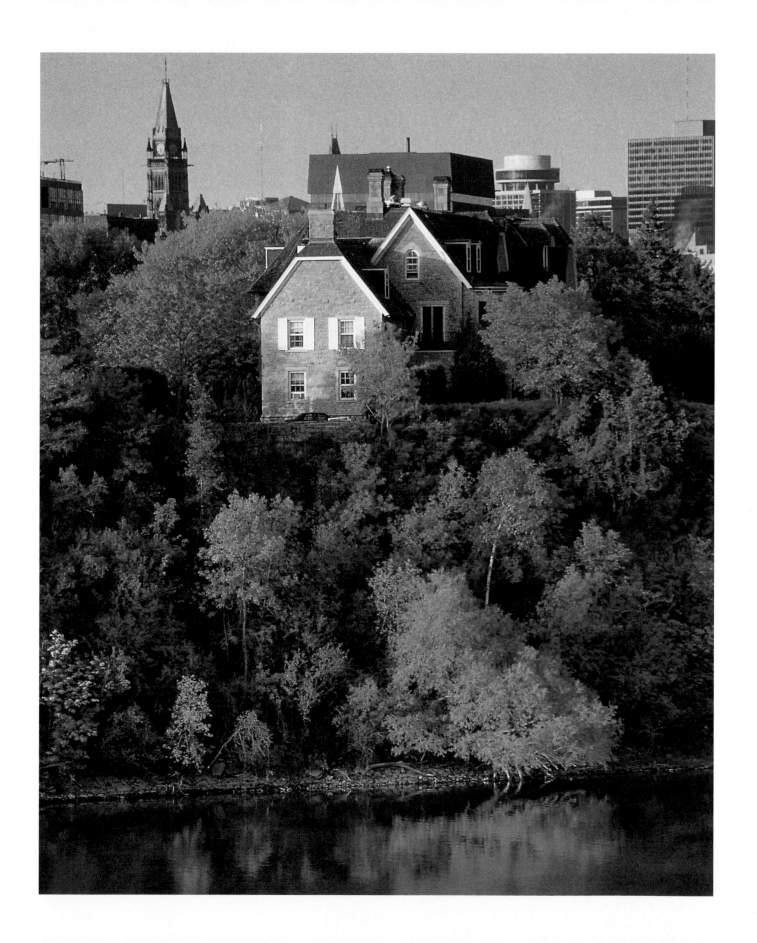

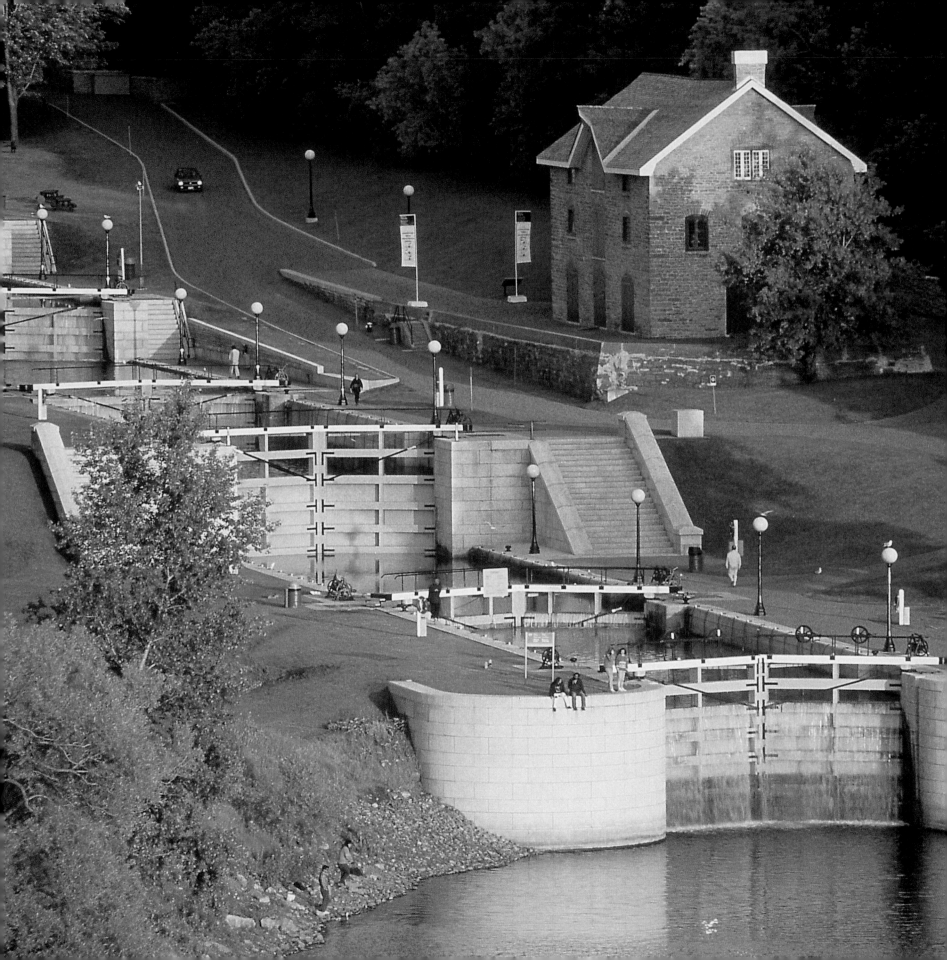

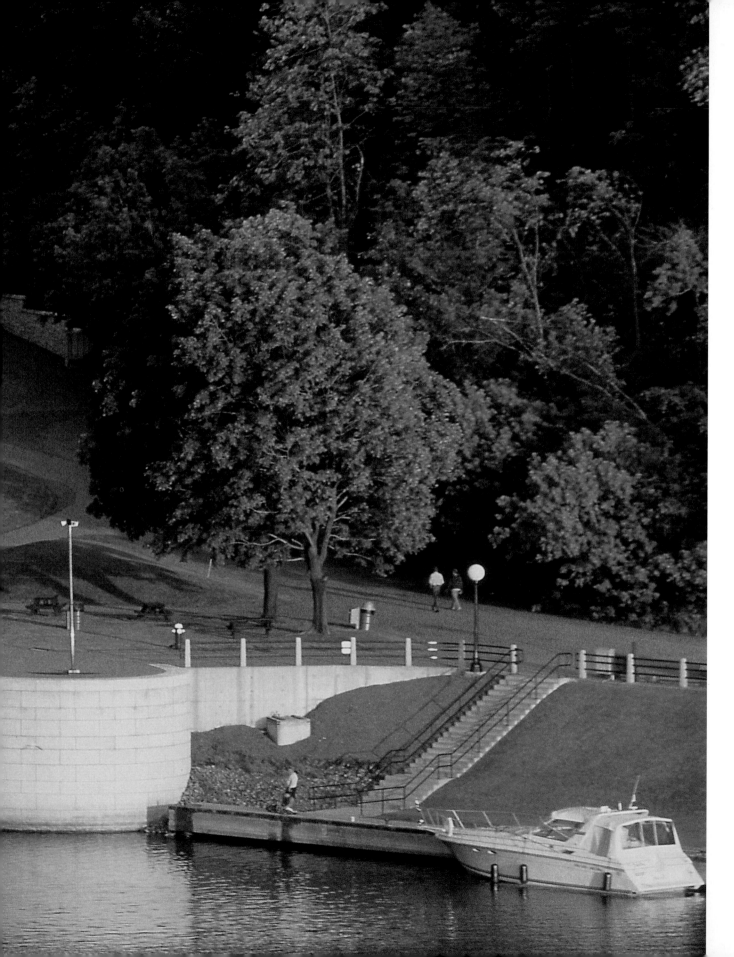

The eight hand-operated locks of the Rideau Canal connect it to the Ottawa River. They were opened for commercial use in 1832 and are now protected as a heritage site.

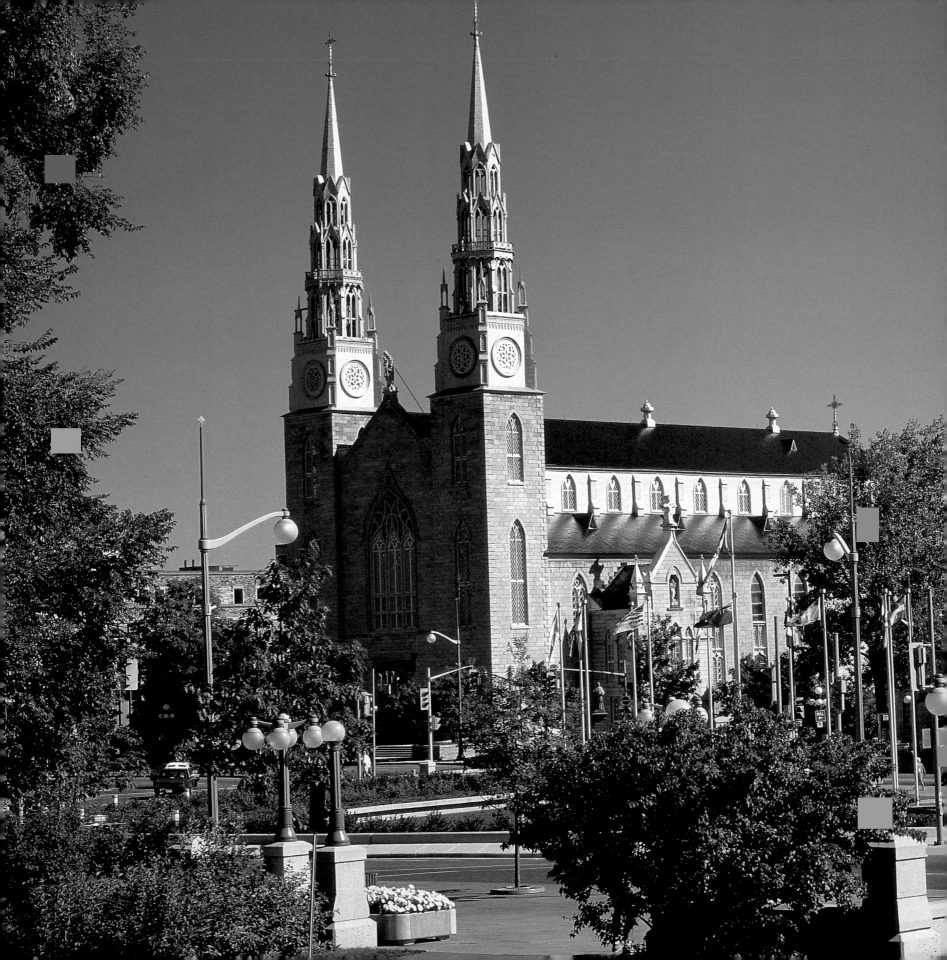

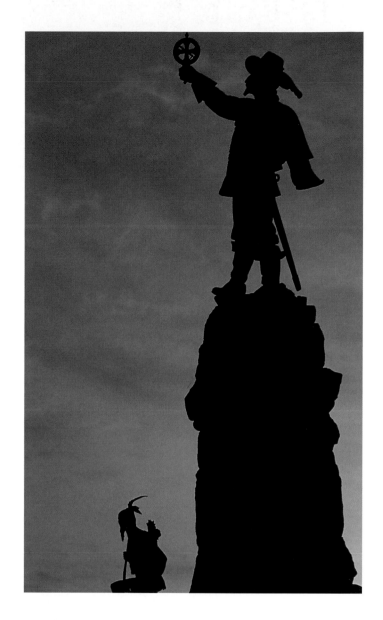

Explorer and cartographer Samuel de Champlain sailed up the St. Lawrence River in 1603. He became known as the Father of New France for his role in the area's settlement.

East Ottawa was originally settled by large numbers of Irish and French Catholics. In 1841, the Notre Dame Basilica was built to serve them. The 55-metre twin spires were added in 1858.

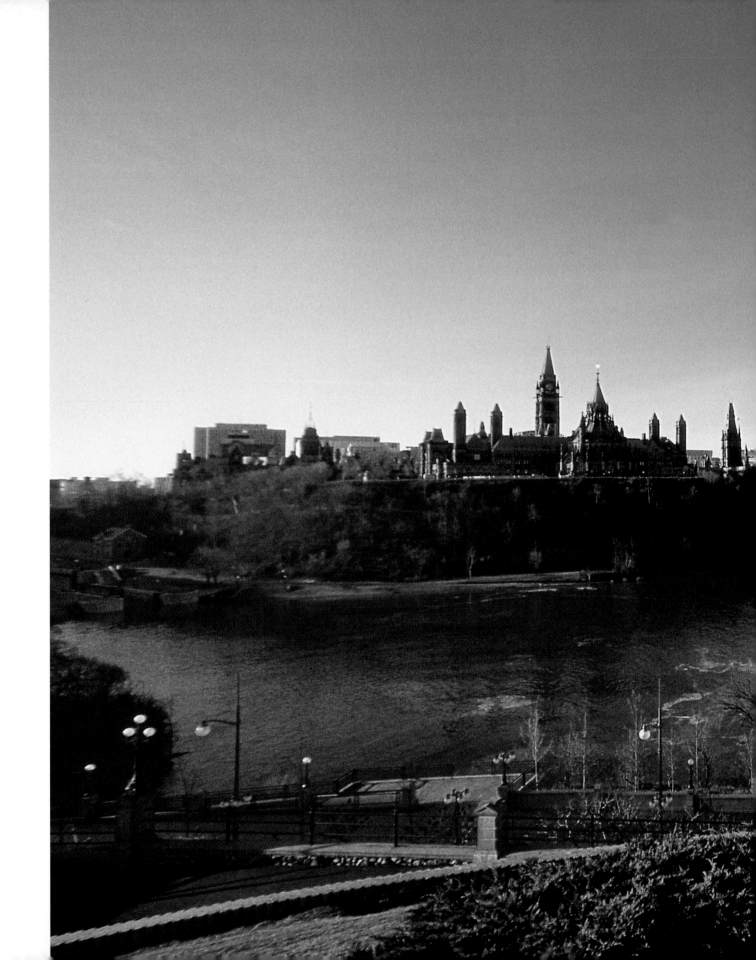

A breathtaking view of the Ottawa River and the Parliament Buildings spreads below the statue of Champlain and his native guide.

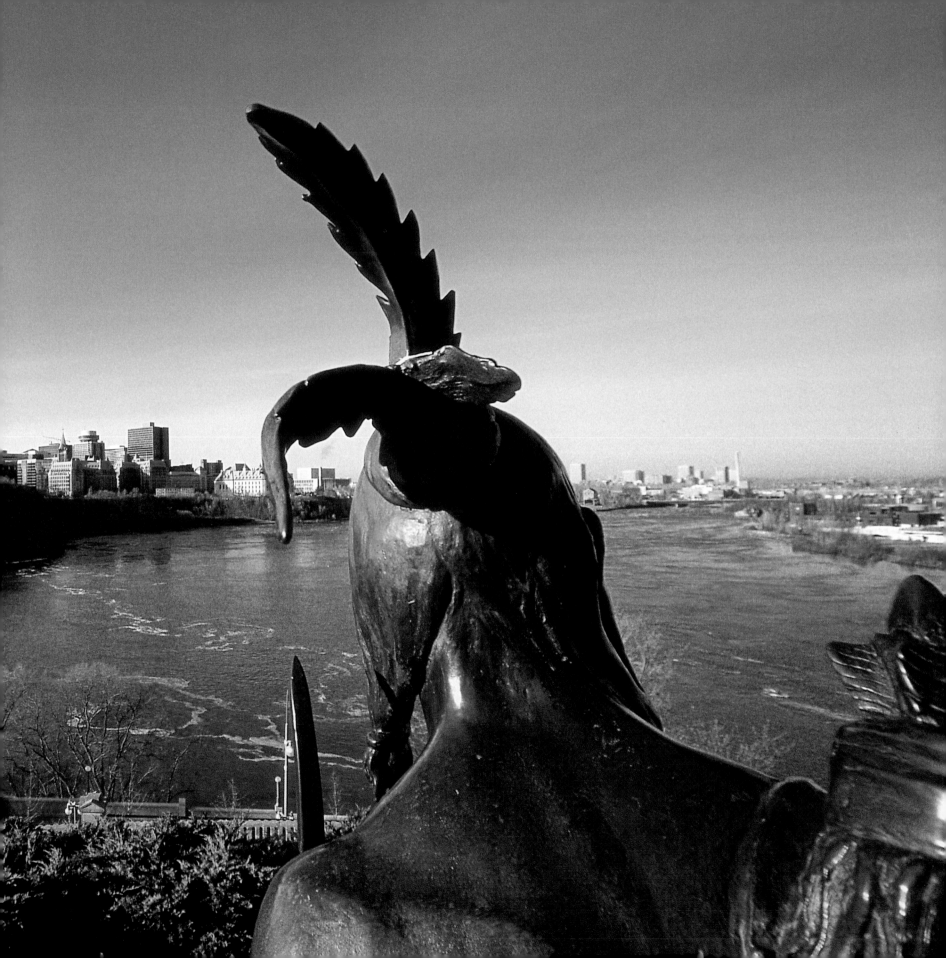

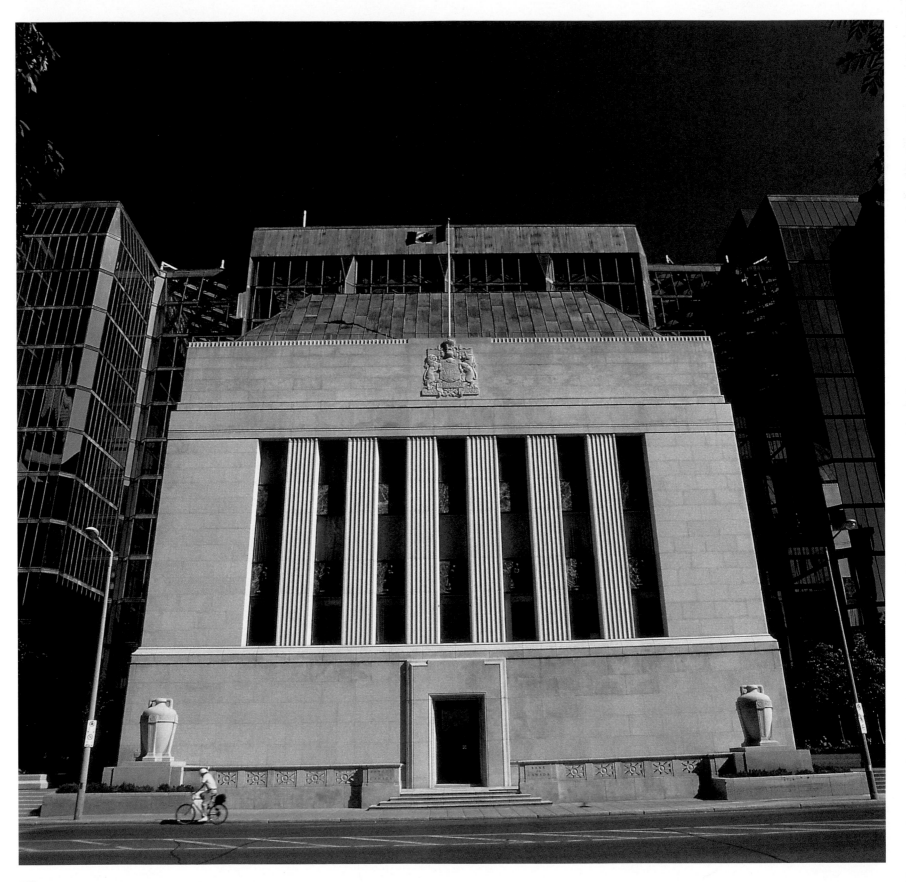

The Bank of Canada combines the stately original structure with the mirrored glass of the new. The government-owned bank was established as the country's centre of money management in 1935. The structure also houses a currency museum with a fascinating array of Canadian notes and coins.

Although it is no longer used for day-to-day currency, the Royal Canadian Mint continues to make special-edition coins and commemorative pieces.

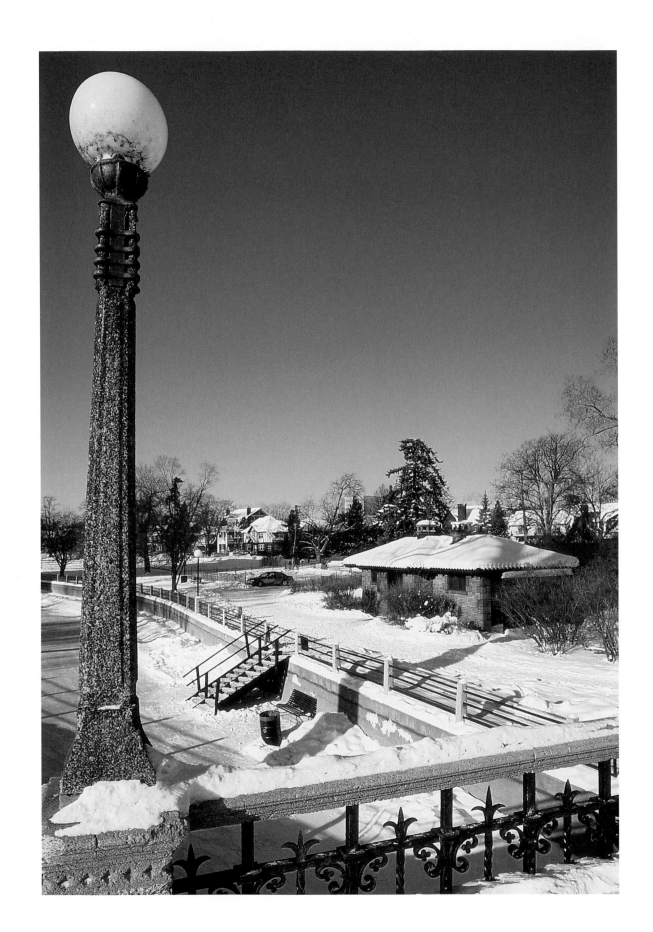

Picturesque homes
overlook the frozen
Rideau Canal.

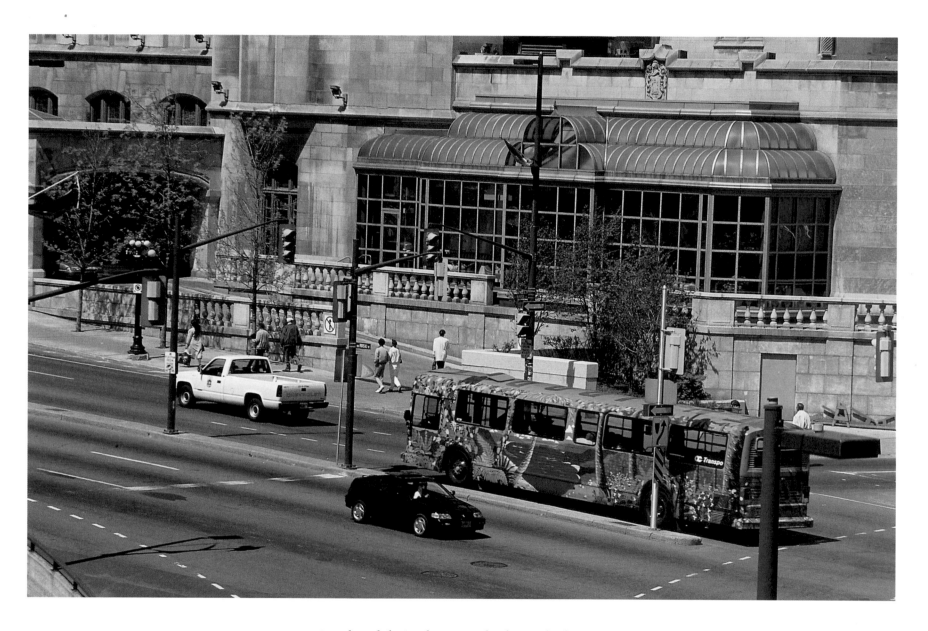

A colourful city bus winds through downtown. Ottawa's public transportation system is one of the best in the country and many roads are reserved specifically for buses.

Overleaf —
In its opera hall, theatre, studio theatre, and salons, the National Arts Centre hosts more than 900 performances a year.

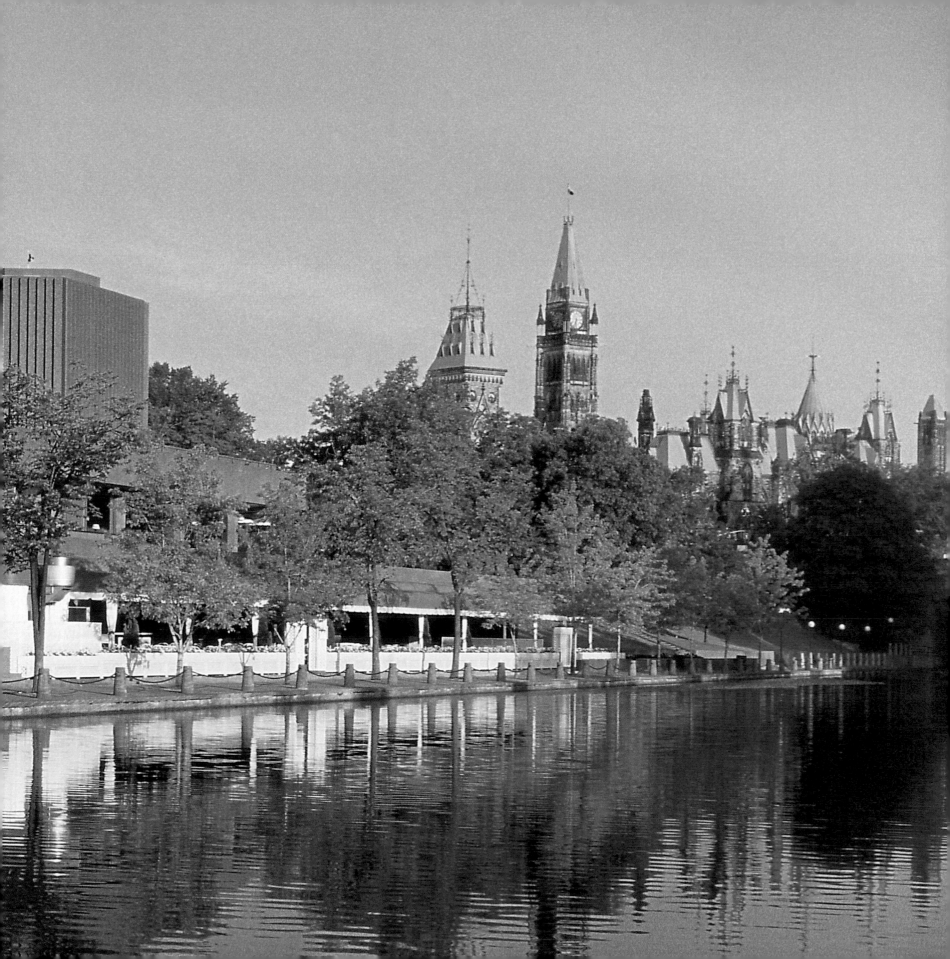

The gigantic barns of Agriculture Canada's Experimental Farm, which house cattle, pigs, sheep, and horses, attract the city's children. The farm's primary purpose is farming and horticultural research.

The Experimental Farm's arboretum
is filled with nearly 2,000 varieties
of Canadian and exotic trees.

Ottawa's small international airport
is just 20 minutes away from the city.

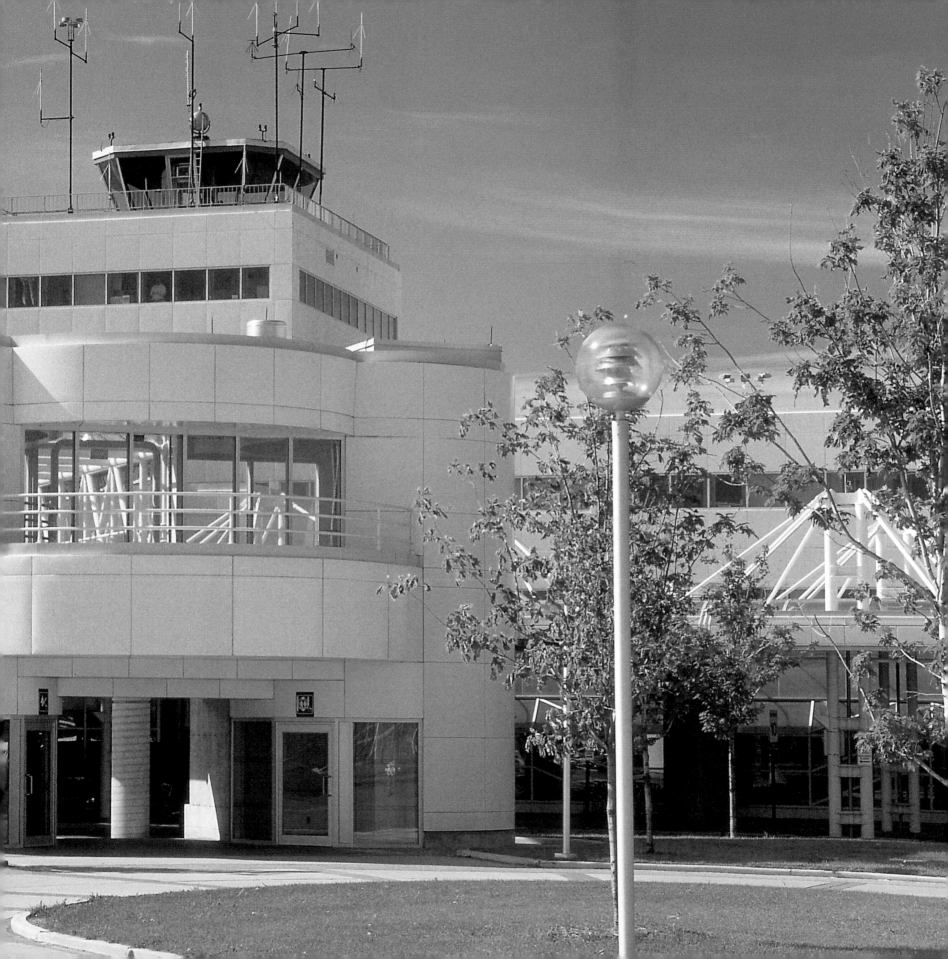

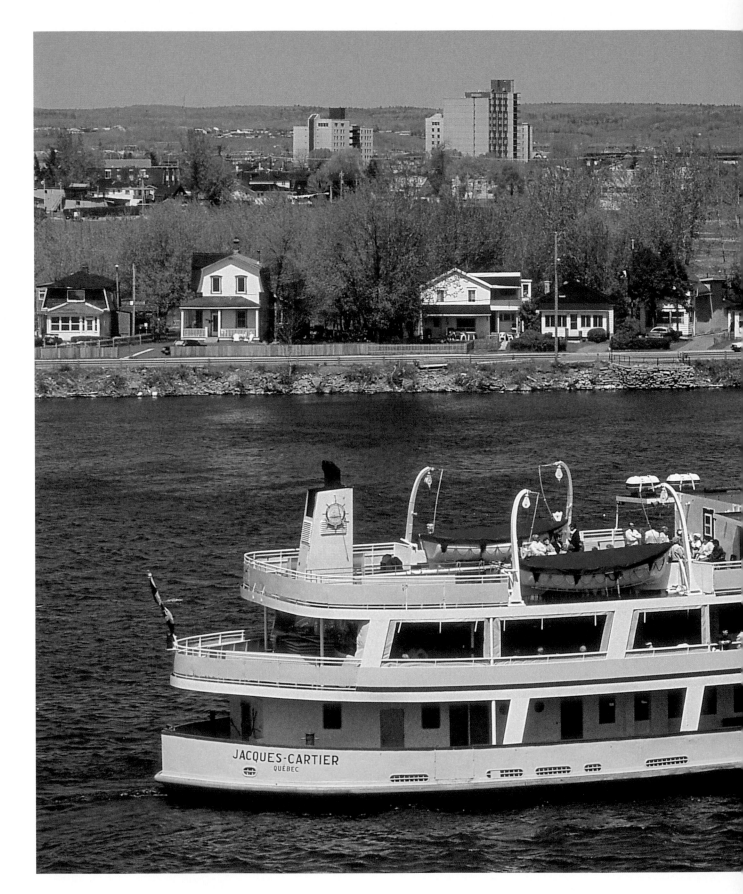

Just across the Ottawa
River, visitors find
rural farmland, the
rolling Gatineau Hills,
and the lively city of
Hull, Quebec.

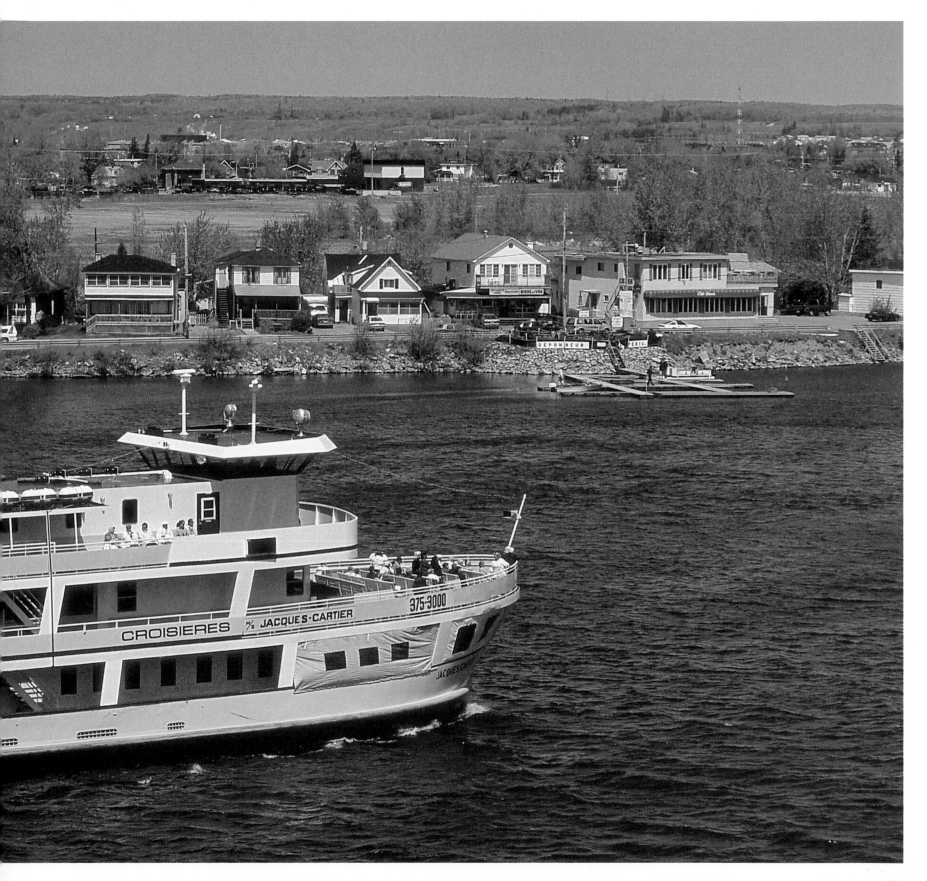

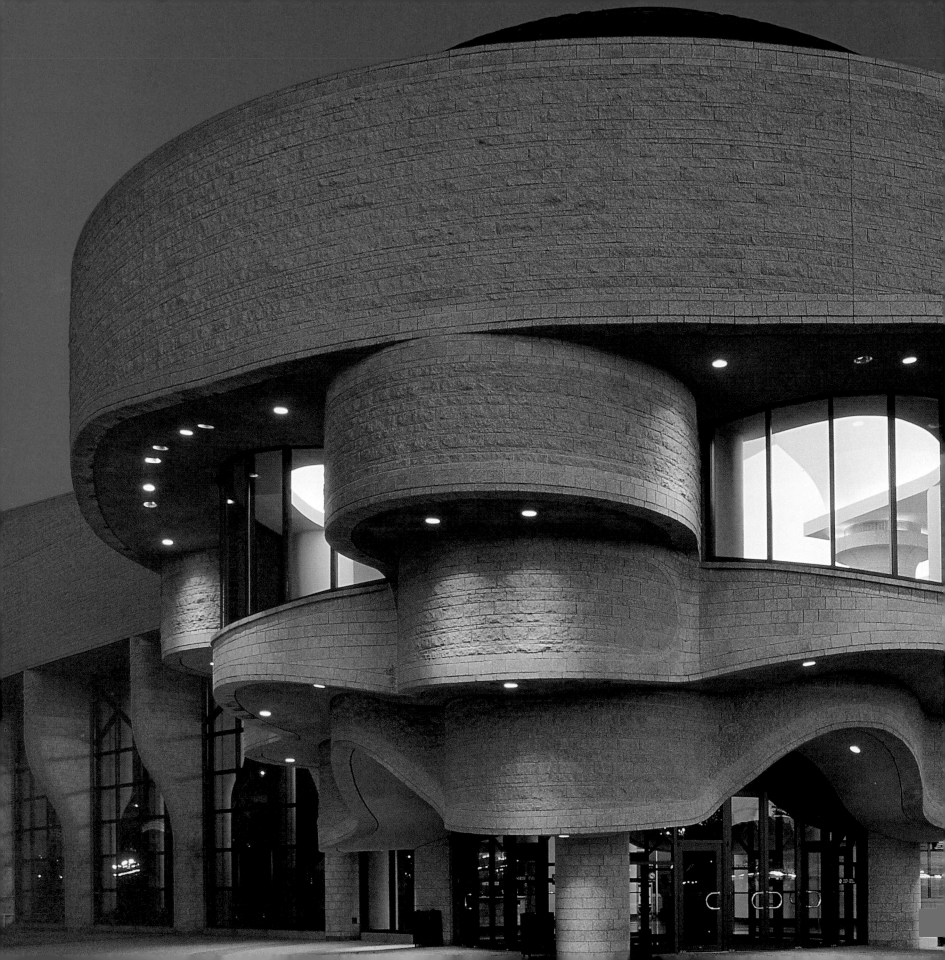

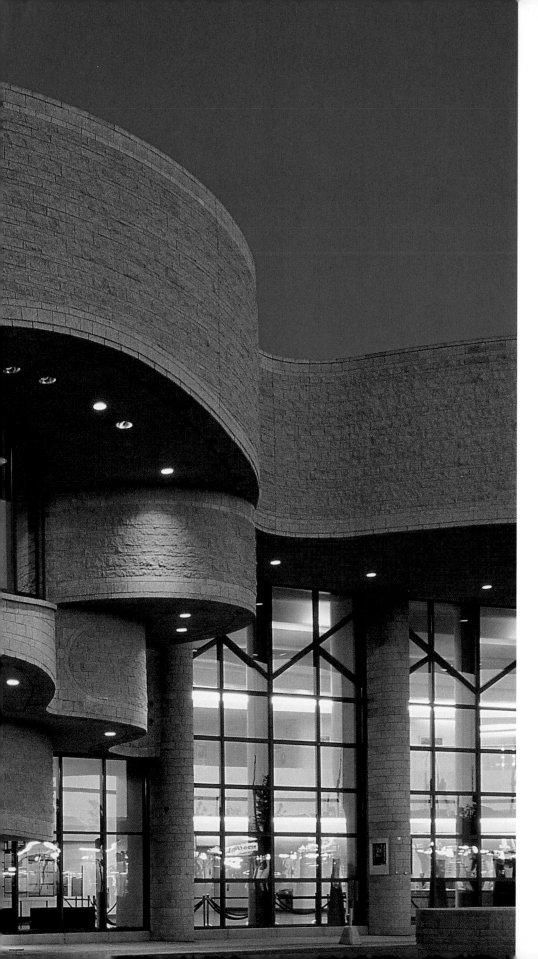

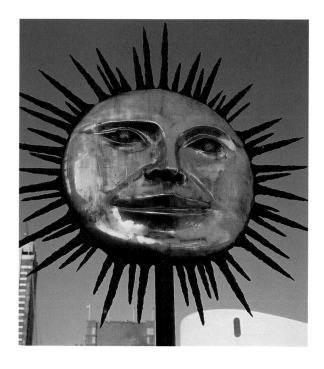

This sculpture, one of many in and around the Museum of Civilization, echoes the blue skies above. Ottawa soaks in an average of 2054 hours of sunlight each year.

Just across the Ottawa River in Hull, Quebec, the Canadian Museum of Civilization displays Canadian history through films, exhibits, and life-size reconstructions.

OVERLEAF –
The museum features First Nations artwork and artifacts from across the country, including the world's largest collection of totem poles from the First Nations of the Pacific Coast.

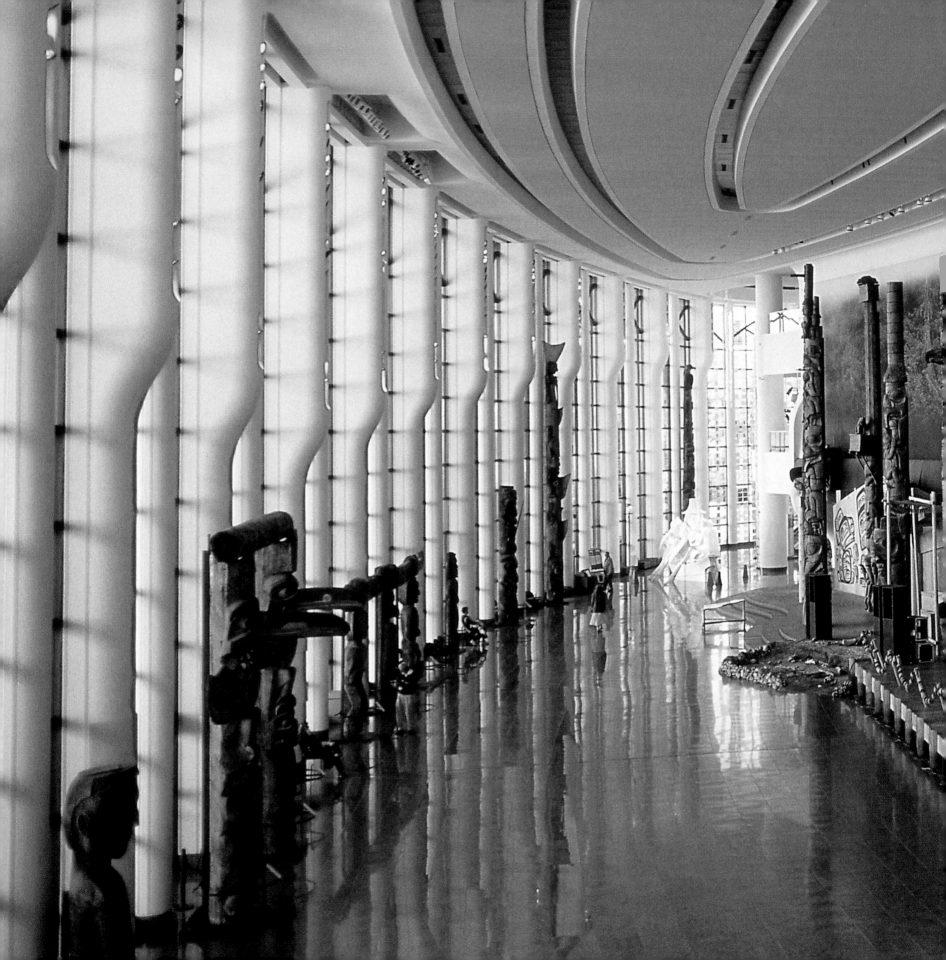

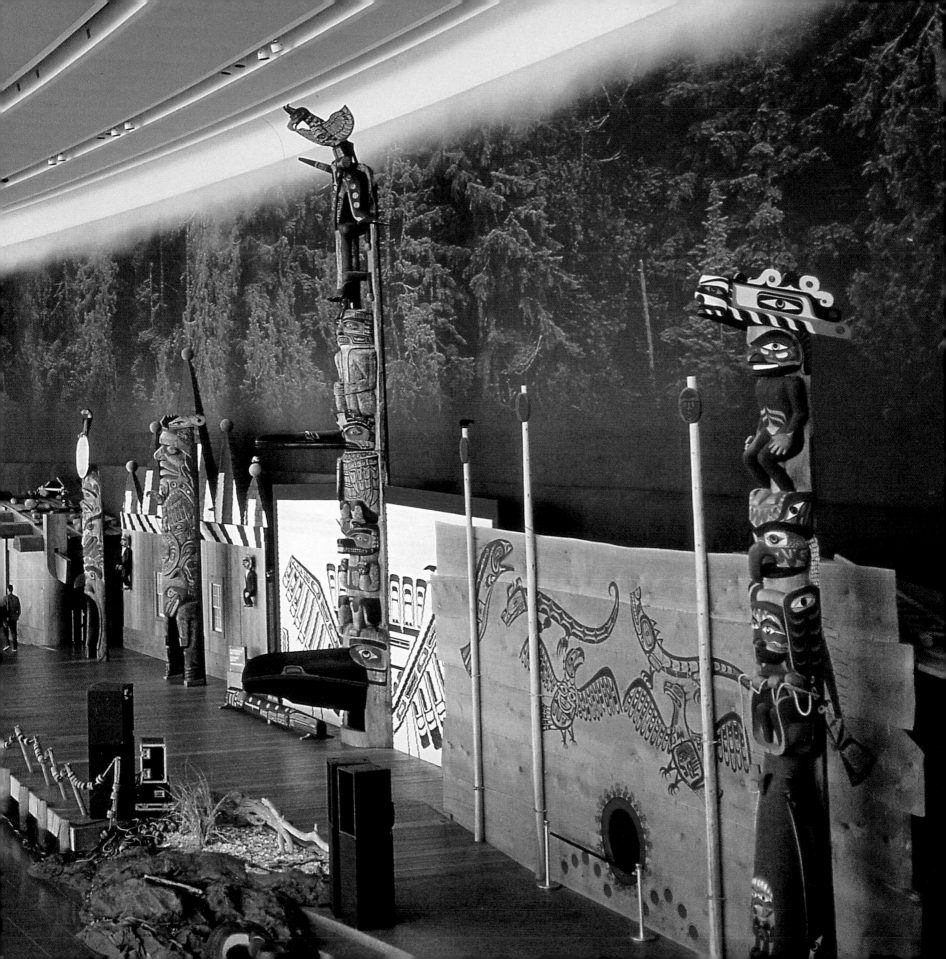

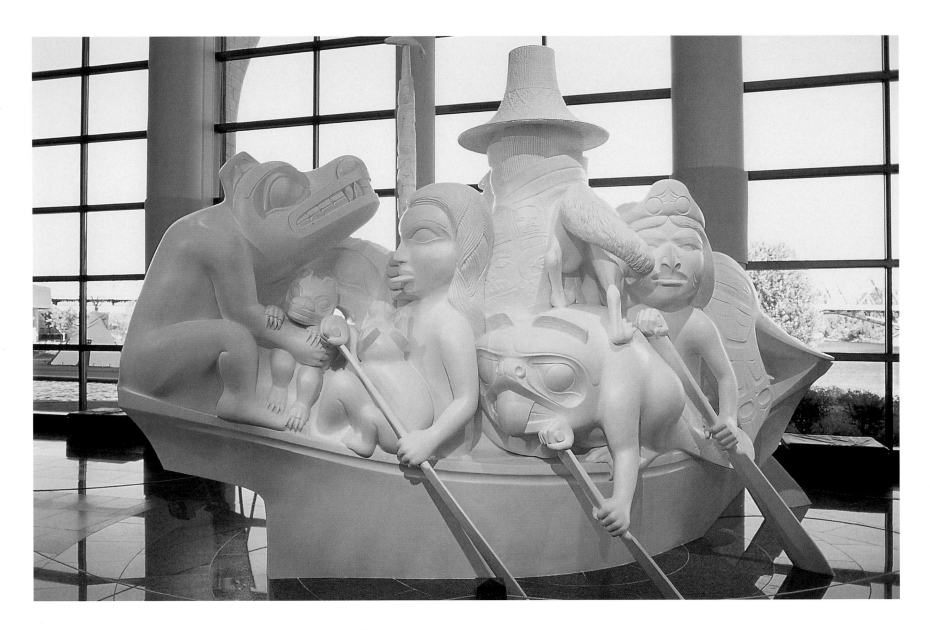

Spotlights at the Museum of Civilization highlight a mold of the *Spirit of Haida Gwaii*, by British Columbia artist Bill Reid. Each of the 13 major figures in the canoe—people, bears, raven, eagle, wolf, frog, mouse woman, dogfish woman, and beaver—are rooted in the mythology of the First Nations of the Pacific Coast. The sculpture itself was made in black bronze and is on display at the Canadian Embassy in Washington.

A native storyteller enthralls museum visitors. Constantly changing live performances and activities, as well as the permanent displays, are what make the Museum of Civilization a local favourite.

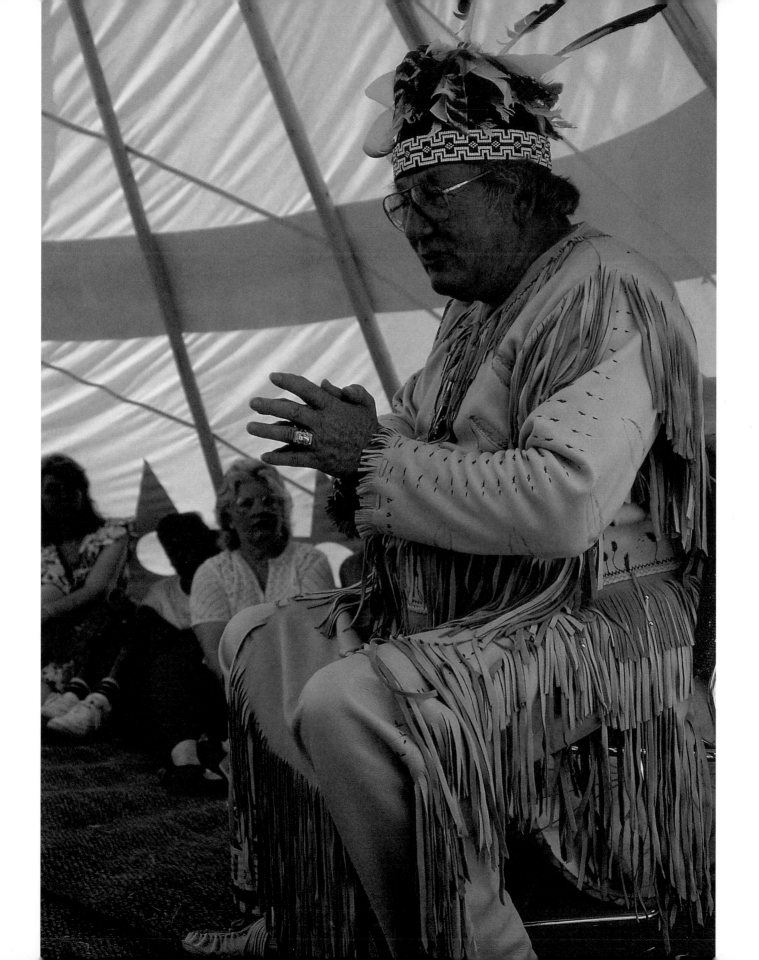

More than a hundred kilometres of hiking trails crisscross Gatineau Park. The 35,000-hectare preserve is home to bears, wovles, birds, and pristine forest.

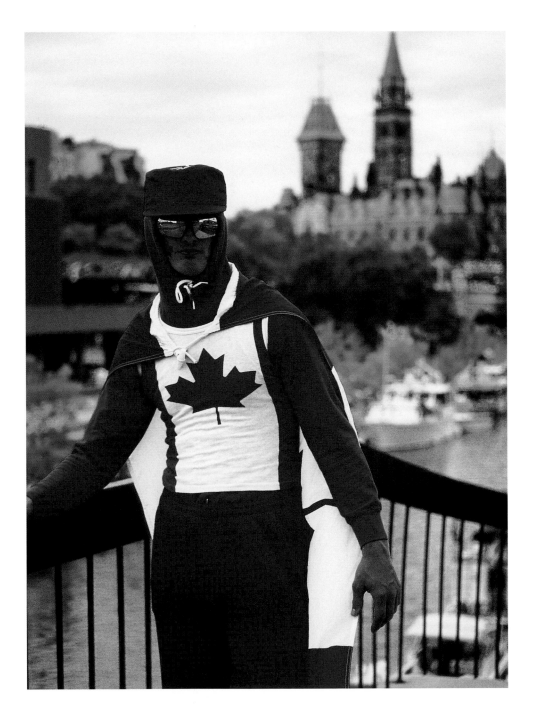

An enthusiastic citizen is dressed
and ready for Canada Day, July 1.

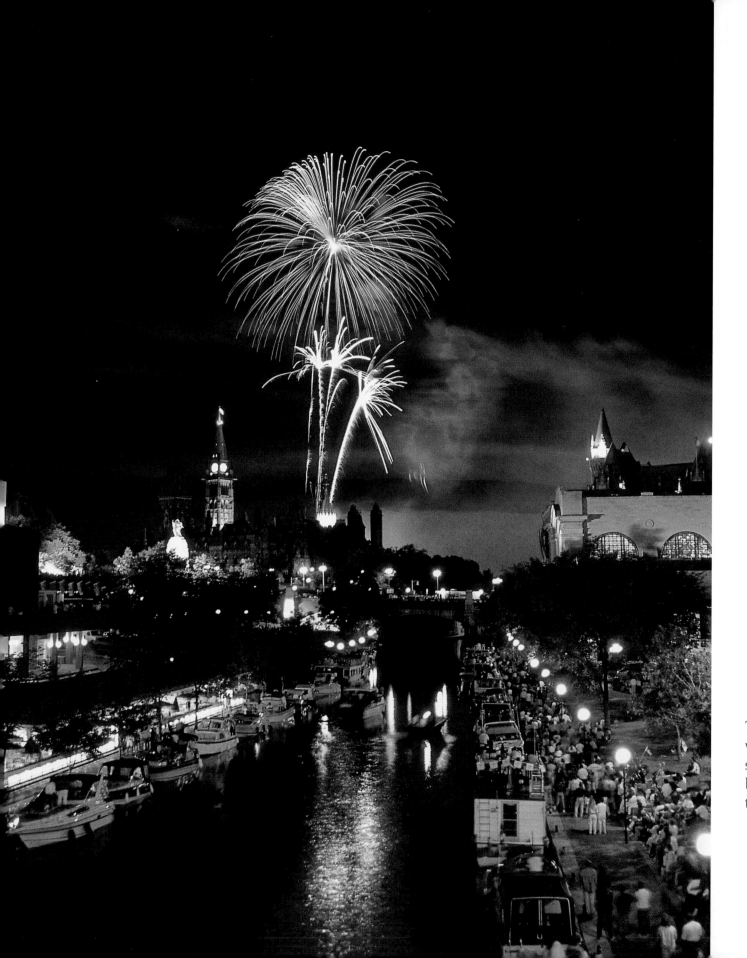

The holiday ends with half an hour of spectacular fireworks, broadcast live across the country.

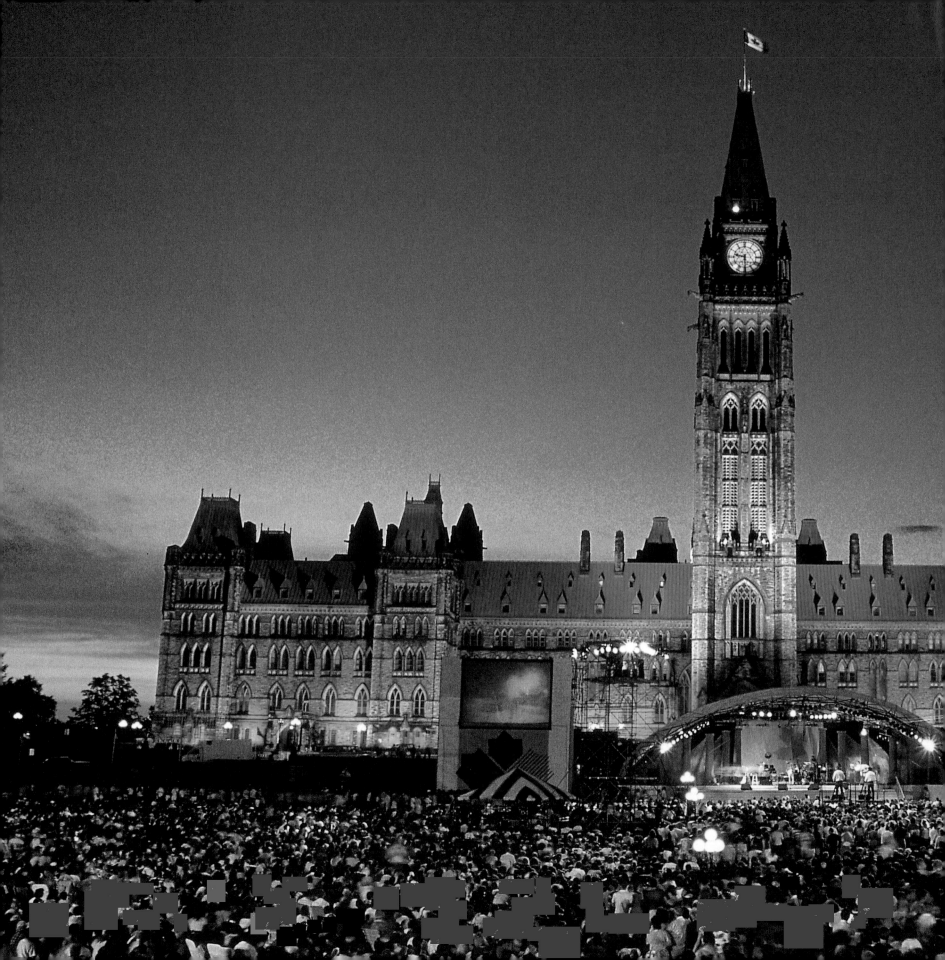

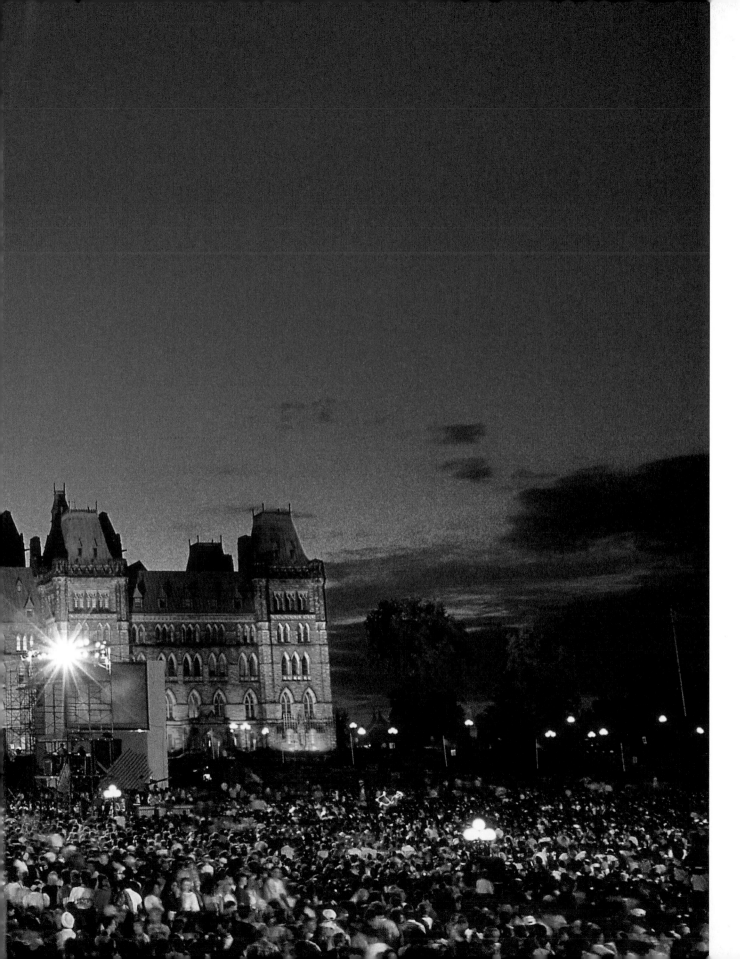

From the Changing
of the Guard in the
morning to music and
fireworks well after
dark, Parliament Hill
is the centre of
Canada Day activities.

Photo Credits